THE ART OF ANIMAL DRAWING

Construction, Action Analysis, Caricature

by Ken Hultgren

DOVER PUBLICATIONS, INC.
New York

This Dover edition, first published in 1993, is an unabridged republication of the work originally published by Sir Isaac Pitman & Sons, Ltd., London, in 1951. This edition is published by special arrangement with A. & C. Black (Publishers) Ltd., 35 Bedford Row, London WC1R 4JH, England. The Publisher is indebted to Murray Debus for having brought this title to our attention.

Manufactured in the United States of America
Dover Publications, Inc., 31 East 2nd Street, Mineola, N.Y. 11501

Library of Congress Cataloging-in-Publication Data

Hultgren, Ken.
 The art of animal drawing : construction, action analysis, caricature / by Ken Hultgren.
 p. cm.
 Originally published: London : Sir Isaac Pitman, 1951.
 ISBN 0-486-27426-8
 1. Animals in art. 2. Drawing—Technique. I. Title.
NC780.H76 1993
743'.6—dc20 92-33086
 CIP

PREFACE

EVER since the day when the first caveman drew animals on the walls of his cave, man has been interested in the art of drawing animals. Then, as now, man sought his inspiration in nature. Strangely enough, in spite of the knowledge of animal anatomy which man has acquired throughout the ages, he has been slow in understanding animal action. One has only to examine a Currier and Ives print of about a century ago to be aware of this fact. Artists of those days depicted the horse running in a stock position — the forelegs high, with knees bent and forward. The rear legs look as though they had just left the ground. Actually, this position never occurs in a run, gallop, canter, or trot.

For a clear understanding of animals, I feel that construction, action analysis, and caricature are all important. It is my intent in this book to give some insight into each of these three phases. It is impossible to include every animal in a book of this size, but complete coverage is not so important as a grasp of a method which may be applied to the drawing of all animals.

Construction is the foundation of all drawing. A detailed knowledge of anatomy, such as knowing the exact number of vertebrae in a deer's spinal column, is not so important as knowing the general structure and the flexibility of the spinal column in animation. One can look at the muscle structure in the same way. Once one understands the general pattern of how muscles are formed on any one type of animal, and has a feeling of their elasticity, he will be better prepared to draw other animals more convincingly, since they parallel each other anatomically in many respects.

Action analysis follows construction, yet the two are allied, since one must know the rudiments of anatomy to understand the capabilities of any animal in motion. The ability to draw a convincing pose lies in the understanding of action.

Just prior to the time of motion pictures, Eadweard Muybridge worked out a system by which he could take a series of photographs of animals in action. His photographs showed gaits of animals that the eye had never been able to catch before. Now, by means of slow-motion pictures, at last we can understand movement. The films reveal some very extreme positions, thus showing us what pliable forms the artist has to work with in drawing animals.

Once you have familiarized yourself with the mechanics and pivot points in the skeleton, as shown in the sketches in this book, you will find that you can express more with the pose of the animal. The artist is not merely a human camera who illustrates precisely what he sees. If that were the case, I would have filled this book with photographs. Nature is the inspiration, and one should have solid groundwork in the understanding of animal anatomy, but the artist's own creativeness should show through the drawing with his interpretation of the mood he desires to express. Most of the sketches in this book were done without models or photographs. When I did use them, they served as a steppingstone rather than as the outright statement of what I wanted to express.

This discussion brings up the third important phase of drawing developed in this book—caricature. It is more imaginative than the other two, since one is creating an impression of the animal by exaggerating his characteristics. This in turn aids in more accurate representation by making one more aware of the outstanding characteristics of the animal. Just as many top illustrators try to capture a mood by exaggerating that mood, I believe we can capture the unique quality we are seeking in the animal by exaggeration.

Animals lend themselves particularly well to caricature, because there seems to be a never-ending variety of contrasting types. Perhaps the most common form of cartoon caricature is achieved by investing the animal with human foibles. Here the parallel in facial expression and body attitude between man and animal is close. A different effect is created by the decorative caricature, which emphasizes characteristics in a medium of harmony of line, stressing design. By either approach the creative faculty of the artist is exercised—another reason for the value of caricature as practice.

If you are a beginner, and are planning a sketching trip to the zoo, or a horse show, or other event where you can observe animals in action, I suggest that you take several soft pencils and perhaps a Conté crayon. The pencils, being soft, will force you to work boldly. The Conté crayon is good in that you can get quick results in blocking in tone. The need for working quickly and boldly is imperative since the animals are constantly changing positions. At times one must be able to catch the essence of the pose in a few fleeting moments. Be aware of form constantly as you work—strive for attitude—get the feel of the animal!

The many basic steps for quick sketching in the drawings in this book should be helpful in catching the essential movement and character of the animals and in avoiding the stiff and wooden poses that are the frequent and unfortunate result of much sketching of animals from life.

A word about the construction drawings in the book. I have put

the emphasis throughout on construction drawings rather than on text. By this means the student is able to view the development process of the drawings by example rather than by theory or description.

Most of the work was done with brush and ink. It's a good medium both for reproduction and for sketching. If you have not tried it and wish to do so, be sure to get a good sable brush — number 2 or 3. Be sure the ink is a good true black, since some popular commercial inks can't take an eraser without fading.

I sincerely hope this book will prove stimulating and valuable to any artist — student, amateur, or professional — who is interested in drawing animals, and that the user will find as much challenge and pleasure in studying it as I have found preparing it.

<div align="right">KEN HULTGREN</div>

August, 1950

CONTENTS

TIPS ON DRAWING ANIMALS

It is well to divide the body into three parts — forequarters, belly, and rear quarters. Since this is a natural division, it aids in achieving proper proportion. Draw in dorsal stripe (line of vertebrae). This helps to center the animal.

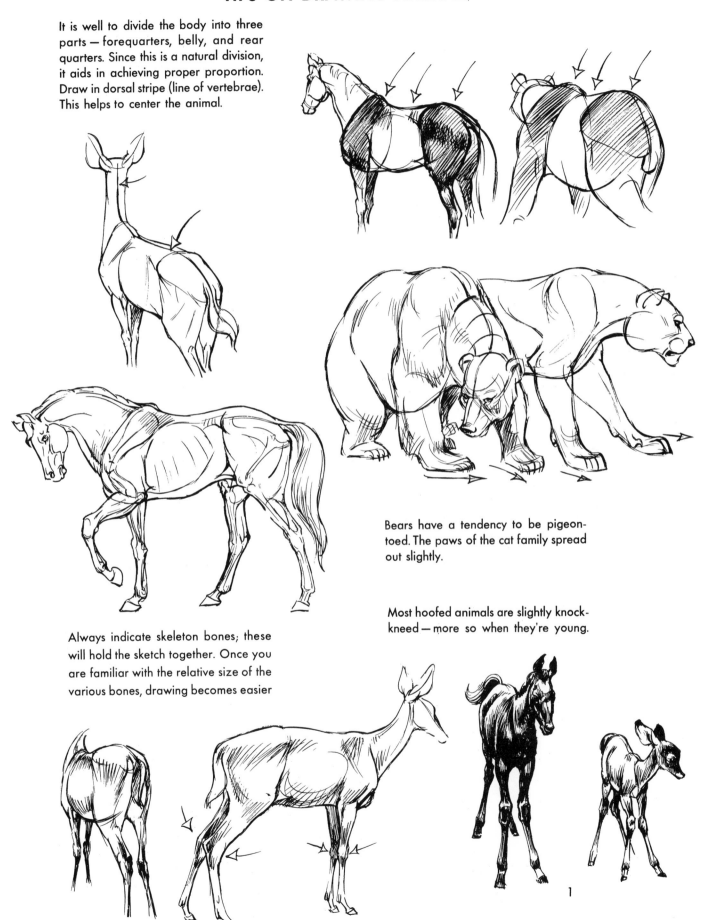

Bears have a tendency to be pigeon-toed. The paws of the cat family spread out slightly.

Always indicate skeleton bones; these will hold the sketch together. Once you are familiar with the relative size of the various bones, drawing becomes easier

Most hoofed animals are slightly knock-kneed — more so when they're young.

1

Divide the skull into three parts also: the muzzle, the long part of the nose, and the base of the skull.

Fasten ears onto the back of the head. For simplicity, indicate the base with an oval.

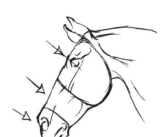

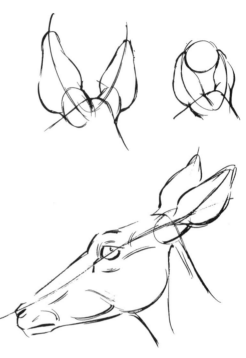

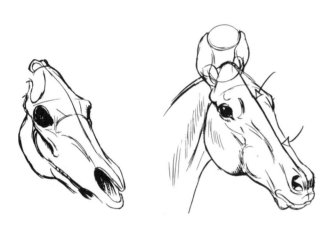

Divide the head in the middle for construction; it's a natural division.

Line up the eye with the ears and nostrils; this is a good guide and is correct for most animals.

Bear in mind that the eyes are usually on the side of the head. Draw your guide lines when constructing.

With bears, cats, and dogs, the eyes are more forward.

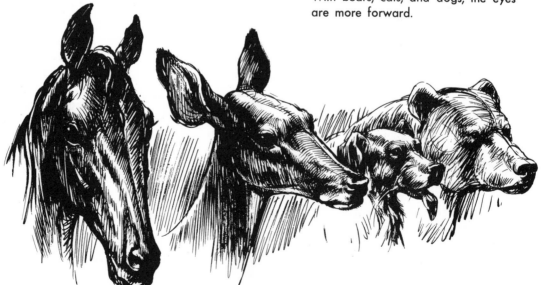

2

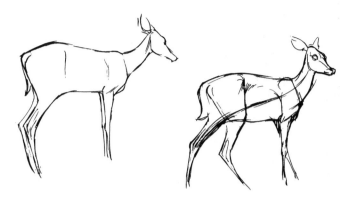

When drawing animals, try to get variety in leg positions. Note the added interest in a sketch when the legs are placed at different angles, in contrast with the stiff, stilted pose with the legs parallel.

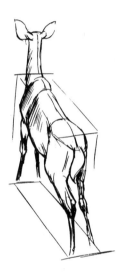

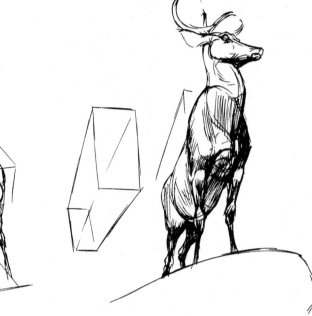

It is well to keep these box forms in mind when working with angle shots. If in doubt about a pose, rough in your box lightly, and check your perspective.

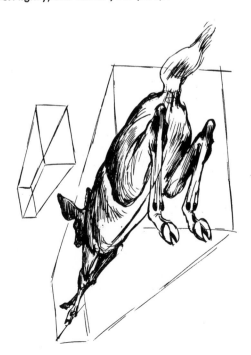

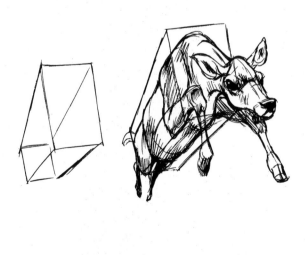

3

SIMPLIFIED SKELETONS

Before concentrating on individual animals, it is helpful to note some facts concerning the skeleton in general.

Once you have acquired some knowledge of the pivot points or joints in a skeleton, your drawing will come more easily.

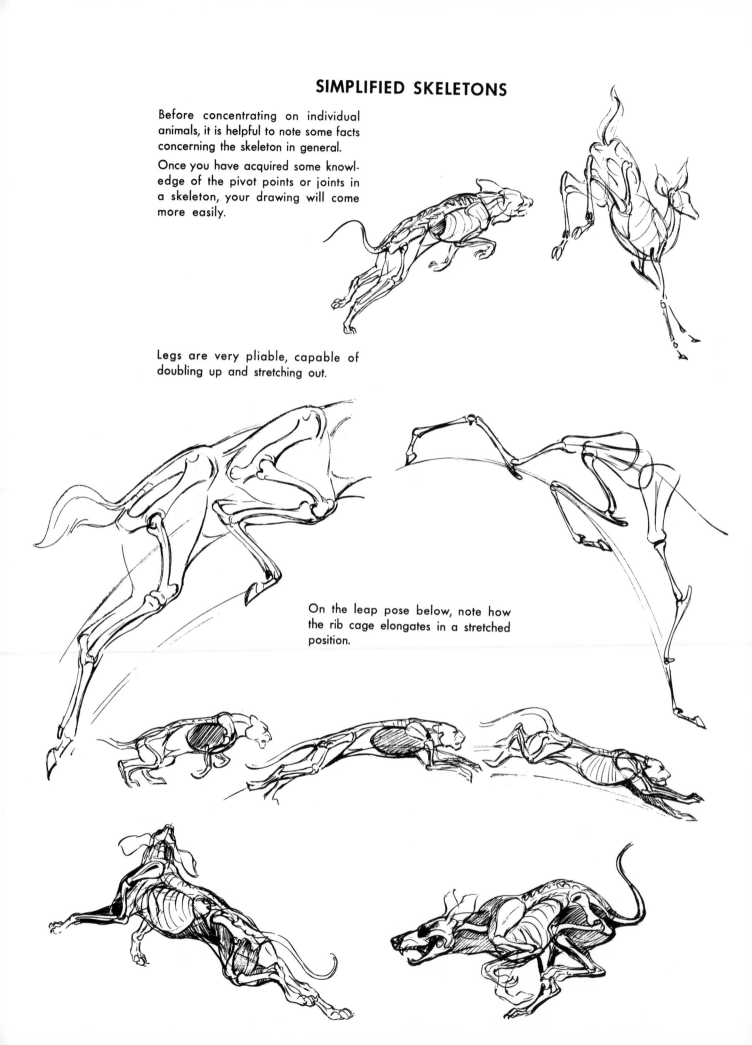

Legs are very pliable, capable of doubling up and stretching out.

On the leap pose below, note how the rib cage elongates in a stretched position.

SKETCHING IN FORMS

Once you have the basic principles of the skeleton in mind, you may proceed with more assurance in your drawing. In sketching, it is helpful to indicate the positions, or pivot points, on the sketch. After locating these, draw the main forms of your animal.

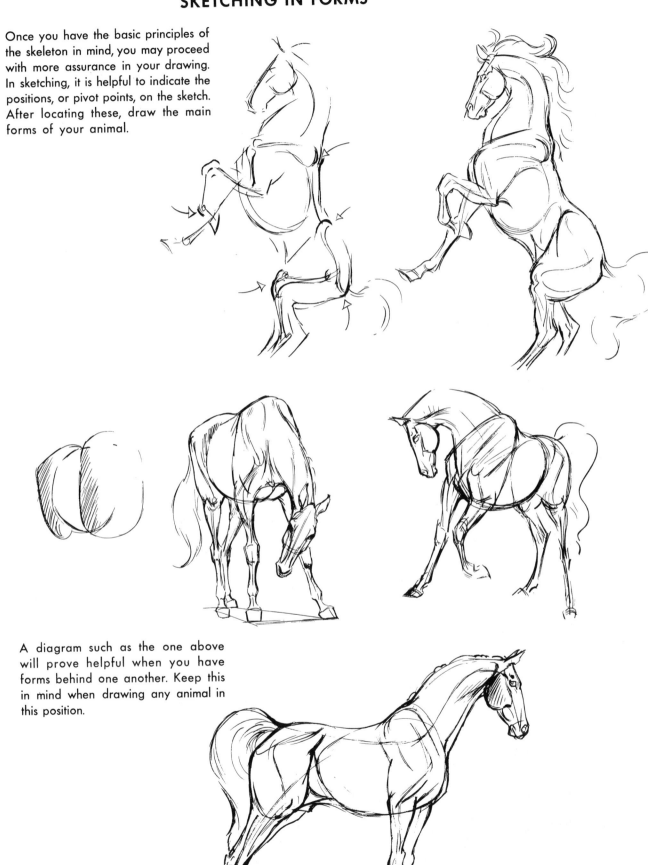

A diagram such as the one above will prove helpful when you have forms behind one another. Keep this in mind when drawing any animal in this position.

5

MANIKIN FRAMES

These manikin-like frames will help you
in working out your construction and
action drawings.

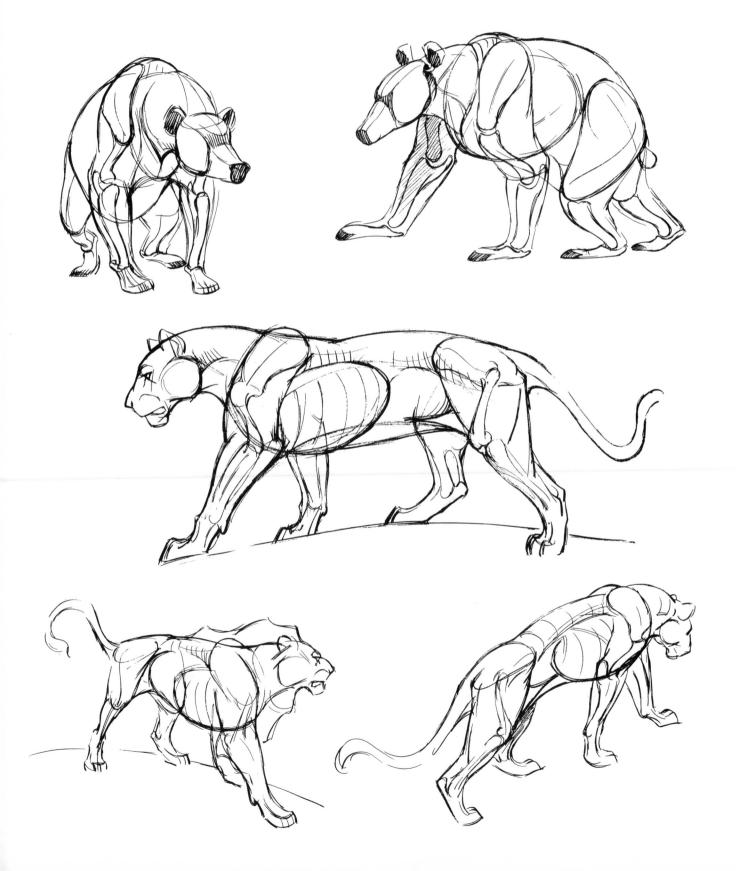

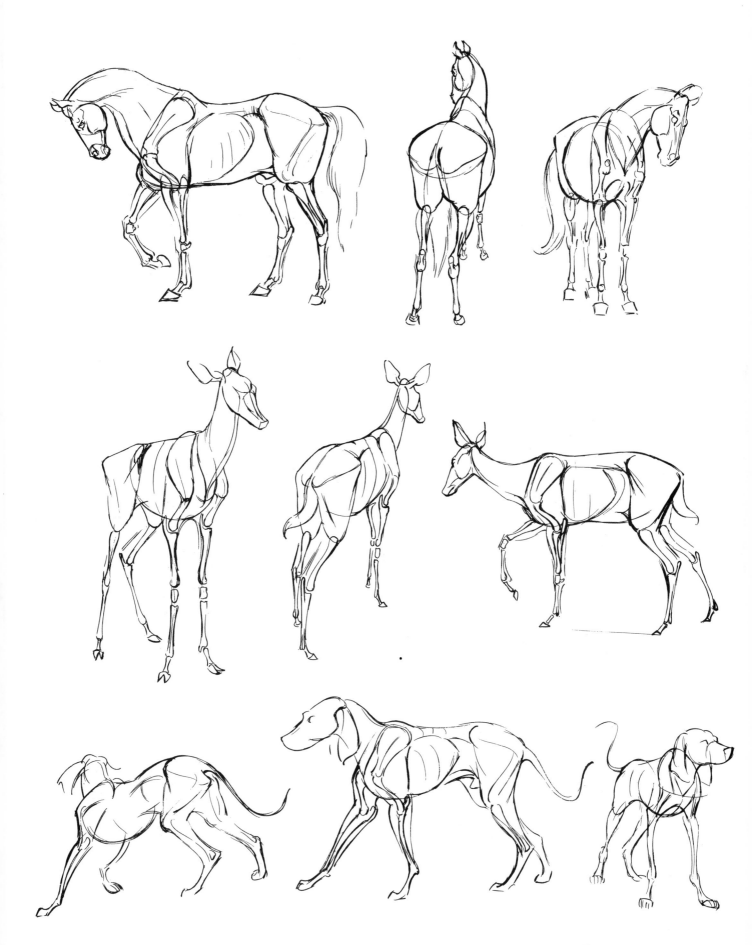

MOOD AND FEELING

Every artist is an actor, in that he conveys to the observer the mood or attitude of his animal characters and must feel the situation before he can put it down on paper. If the mood is a tense one, such as that of the deer group, then you strive for a taut, tense mood in your characters. At such a time, animals drop lower on their hindquarters, prepared for a quick departure if the situation warrants. The ears and tail are perked up. The whites of the eyes are seldom visible in animals except when they are extremely tense and frightened. In the deer sketch, the stretched necks also help to convey tension.

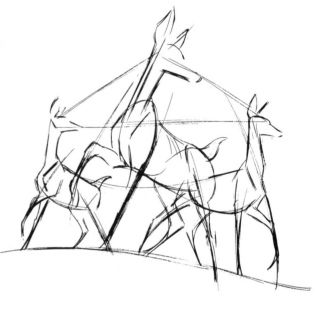

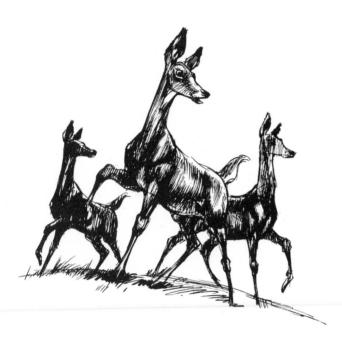

In a very tired pose, like that of the horse, the effect requires as much droop as possible. Animals shift their weight from leg to leg when tired. Their heads hang low. Keeping the withers high accents that effect.

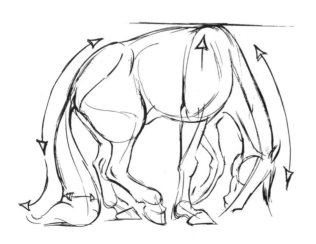

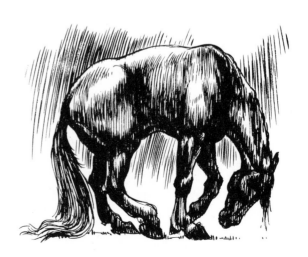

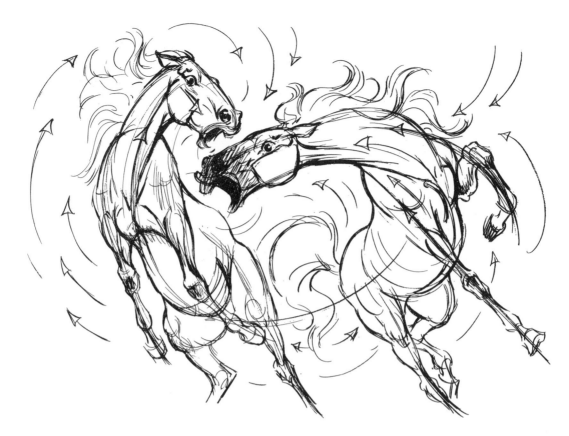

To convey excitement, flaring the manes
of the horses was helpful. The nostrils are wide,
ears back, and the whites of the eyes visible.
The neck muscles are taut.

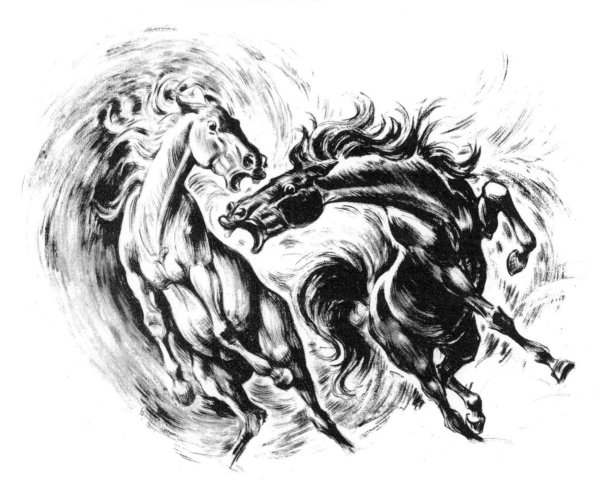

The best way to stage the cowering pose for the dogs seemed to be to keep the heads low, with their attention drawn up. The rear quarters are dropped, and the tails are between the legs.

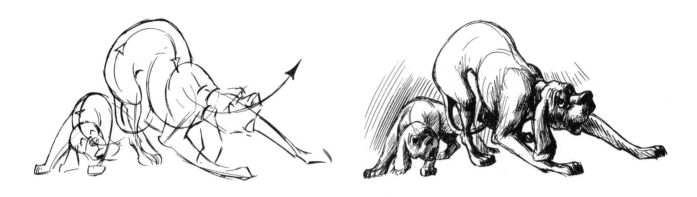

The lions below express a mood of lazy contentment. Like their domestic cousins, lions lazily swish their tails in relaxed moods such as these. The head of the farther animal resting on the other cat's back gives the scene a quiet peace.

Whatever the mood, see it mentally before you start to work. It may be necessary to sketch several rough poses before you find one which you feel is satisfactory. The following are good test questions to ask yourself: Will this pose convey the meaning in silhouette? Is my staging clear? How can I make this pose stronger?

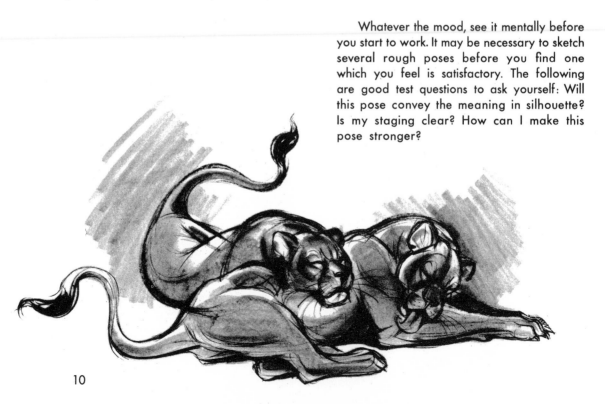

10

THE USE OF LINE

Basically there are two kinds of line: a straight line, and a curved line of varying degree. Primarily we use line to build form and solids and to create movement.

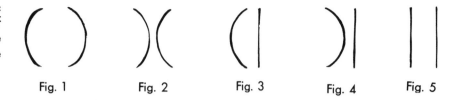

Fig. 1 Fig. 2 Fig. 3 Fig. 4 Fig. 5

Here are some basic lines used to build forms and solids.

An example of Fig. 1 is the cat. Note heavy lines in these examples.

Fig. 2

Fig. 3

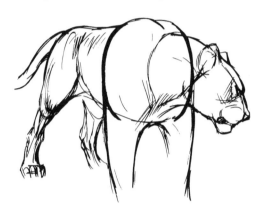

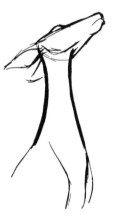

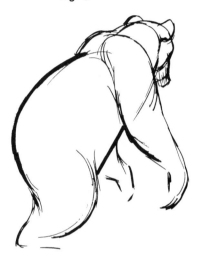

Fig. 3 is a good one also to create weight in horizontal view.

Fig. 4

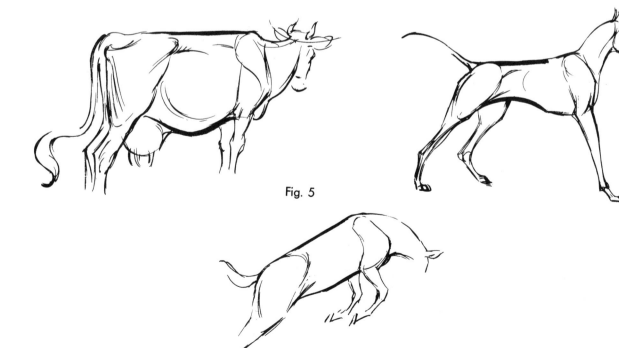

Fig. 5

11

The next use of line is to create motion.

With this arc two directions of movement have been started.

To create more movement, reverse the arc.

To build further, use the straight line, which relieves the monotony of all curves.

In this step, note how the stomach line opposes the leg line. Opposition is always good because it is a part of good composition. Work forces against forces.

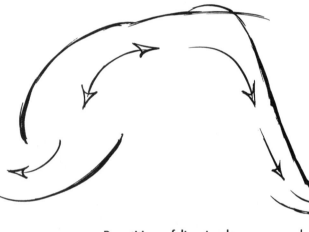

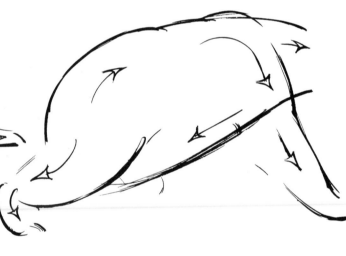

Repetition of line is also very good, since it furnishes a necessary contrast to opposition. Note bear's right rear leg and the line of the stomach.

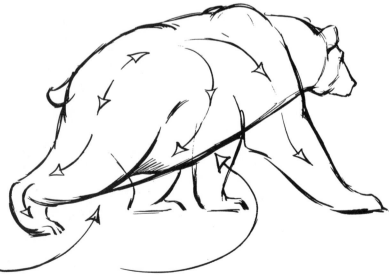

Remember your horizontals, verticals, and diagonals. Every picture should have them.

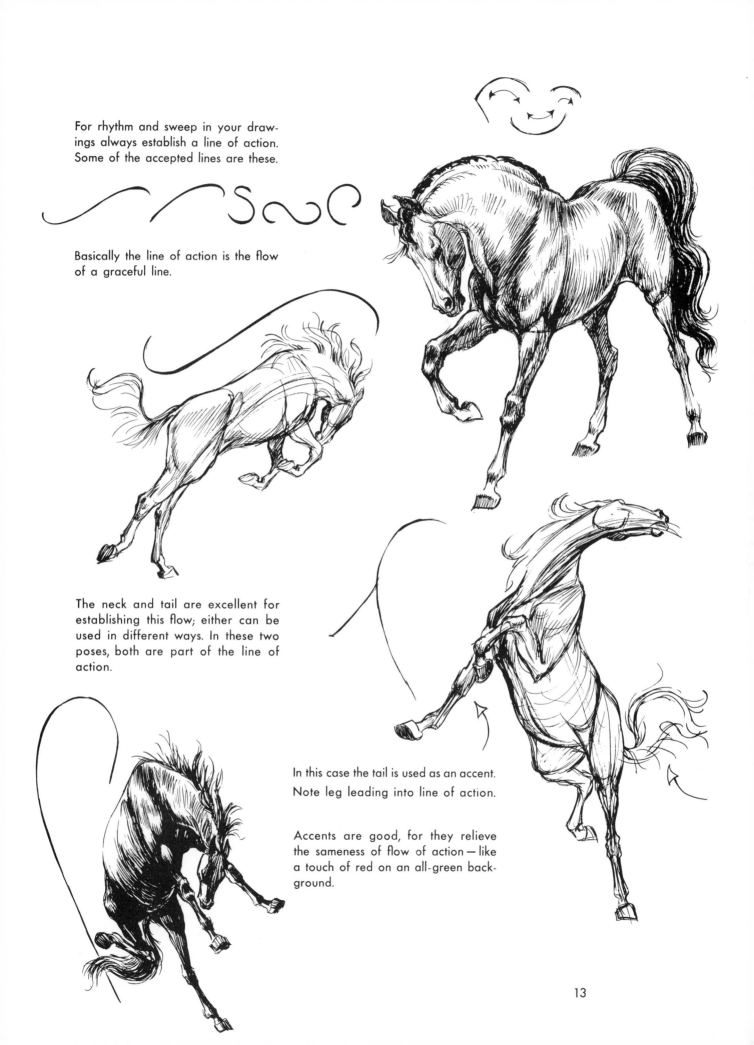

For rhythm and sweep in your drawings always establish a line of action. Some of the accepted lines are these.

Basically the line of action is the flow of a graceful line.

The neck and tail are excellent for establishing this flow; either can be used in different ways. In these two poses, both are part of the line of action.

In this case the tail is used as an accent. Note leg leading into line of action.

Accents are good, for they relieve the sameness of flow of action — like a touch of red on an all-green background.

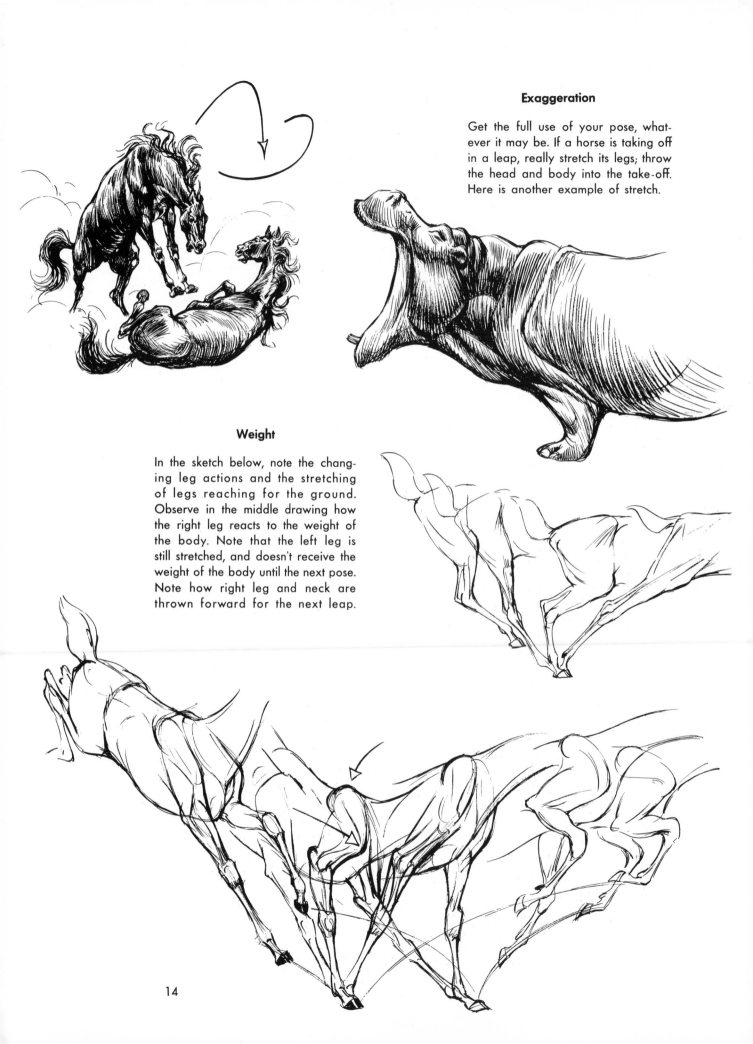

Exaggeration

Get the full use of your pose, whatever it may be. If a horse is taking off in a leap, really stretch its legs; throw the head and body into the take-off. Here is another example of stretch.

Weight

In the sketch below, note the changing leg actions and the stretching of legs reaching for the ground. Observe in the middle drawing how the right leg reacts to the weight of the body. Note that the left leg is still stretched, and doesn't receive the weight of the body until the next pose. Note how right leg and neck are thrown forward for the next leap.

14

ACTION ANALYSIS — ANIMATION

Feel weight, stress and strain, action and reaction.

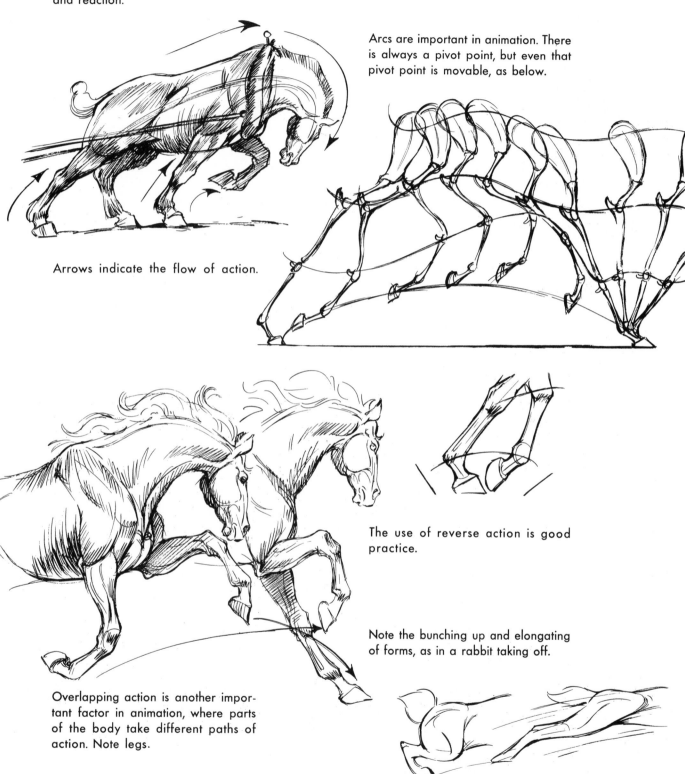

Arcs are important in animation. There is always a pivot point, but even that pivot point is movable, as below.

Arrows indicate the flow of action.

The use of reverse action is good practice.

Note the bunching up and elongating of forms, as in a rabbit taking off.

Overlapping action is another important factor in animation, where parts of the body take different paths of action. Note legs.

ACTION ANALYSIS — IMPACT

Like a rubber ball which elongates in falling and squashes on impact, so a living body will react in comparable circumstances. In his descent, the horse has thrown his head back, his stretched forelegs are reaching to prepare for the impact, and his body elongates in his fall. The legs are first to react, taking his weight at the first shock of his fall. His head pulls downward, and his whole body reverses as he starts his roll. The ball on the rebound elongates again, although not as much as in the original fall, since it has lost some of its momentum. Similarly, the horse in this case regains more of his normal shape as he slows down in the roll.

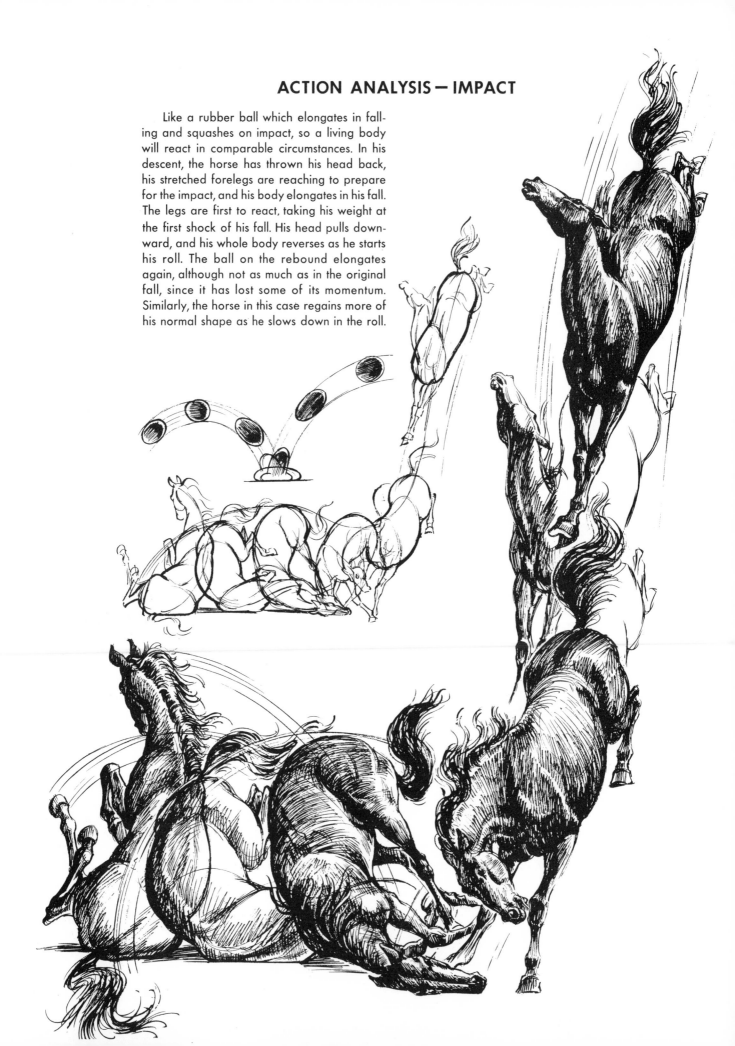

BRUSH TECHNIQUE

Brush and ink is an excellent medium for drawing animals. Since the fur textures of animals vary, your brush technique will vary also. To show the high sheen of a race horse, for example, I keep my brush stroke thin, close together, and even, leaving open areas to suggest high lights.

Shagginess, which is a characteristic of some camels, dogs, etc., may be conveyed by a dry-brush style. This is obtained by thinning out your brush on scratch paper after you have dipped it in ink. The desire here is to have the tip of the brush flat, with the thin edges of the hairs of the brush just wet enough to give a soft tone. The wetness of the brush and the pressure of the brush on the paper determine the tone value you will achieve.

Regardless of the technique, I always hold my brush as I would a pencil, using wrist action for my brush strokes.

Here are some practice exercises for the two styles described.

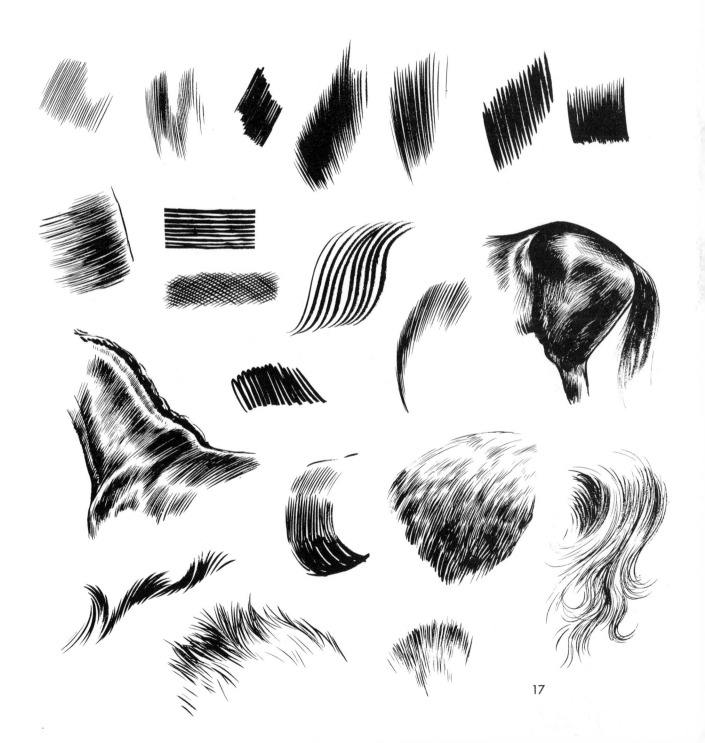

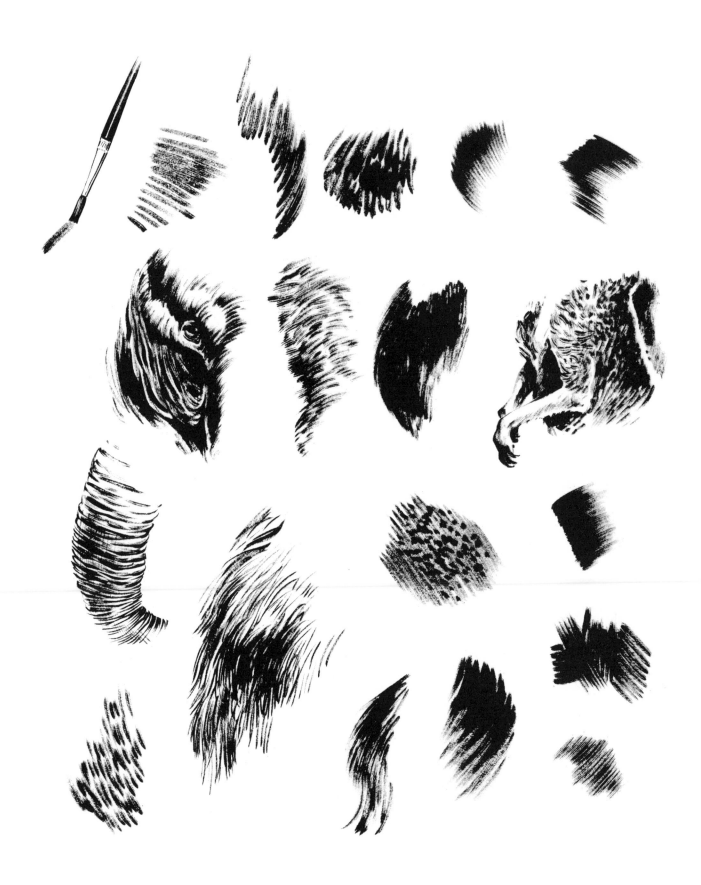

18

THE HORSE FAMILY — Bone Structure

Without knowledge of the principles of bone structure, it would be difficult to show construction, animation, or caricature. Naturally the skeleton varies with the conformation of each type of animal, but there is a basic similarity in the skeletons of all animals. Here is a simplified approach for the skeleton of a horse.

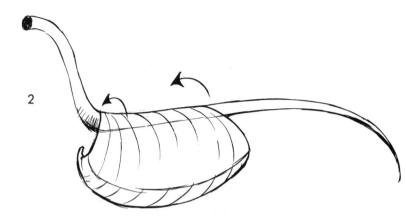

2

Build on the rib cage (here the rib details are omitted).

'1

Starting with the spinal column, treat it, for the sake of simplicity, like a rubber hose, tapering down to a point at the tail end.

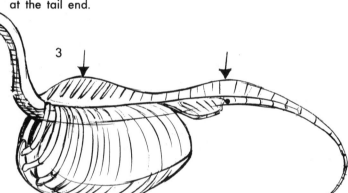

3

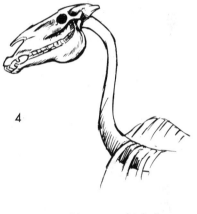

4

Now attach skull.

Next add the vertebrae, simplified again. Note variety in shape. The two high points are support for leg bones.

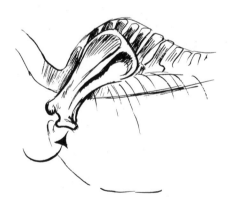

6

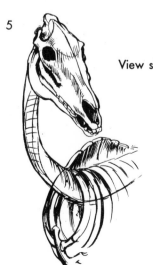

5

View showing shape of skull.

Next attach the scapula. Arrow points to socket for humerus bone.

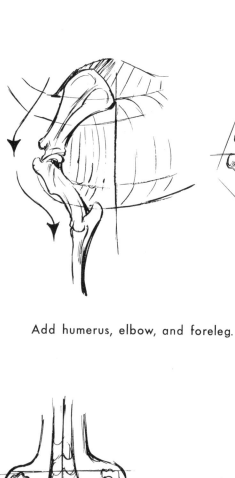

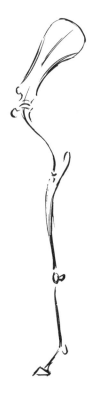

Add humerus, elbow, and foreleg.

Finished leg. For sketching purposes, you can think of it as simply as this.

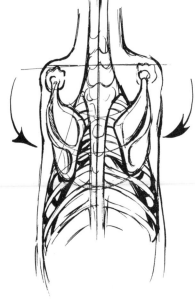

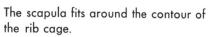

The scapula fits around the contour of the rib cage.

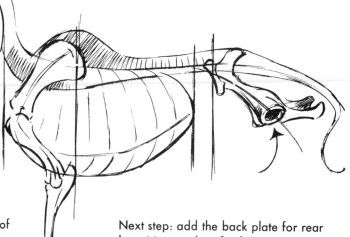

Next step: add the back plate for rear legs. Note sockets for legs.

Perspective view of back plate and socket.

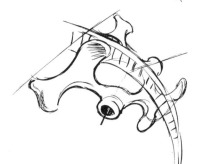

20

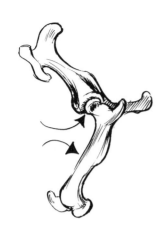

Bone fits into socket.

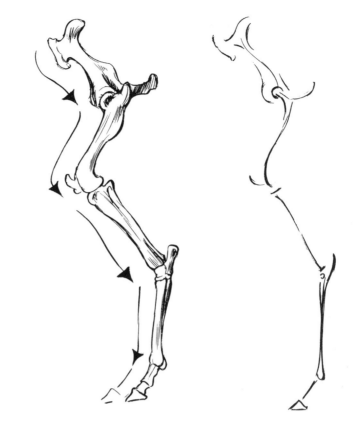

With the building downward of the rear leg, the skeleton is completed.

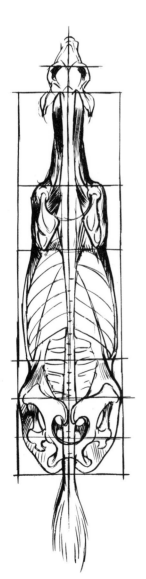

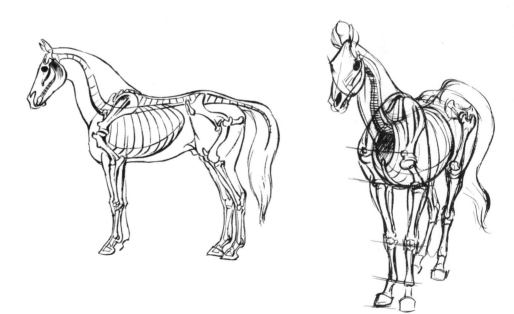

Finished sketches of bone structure

Study each skeleton with the related drawing. Observe how flanks turn out and knees turn in on hindquarters — also slight knock-knee in standing pose.

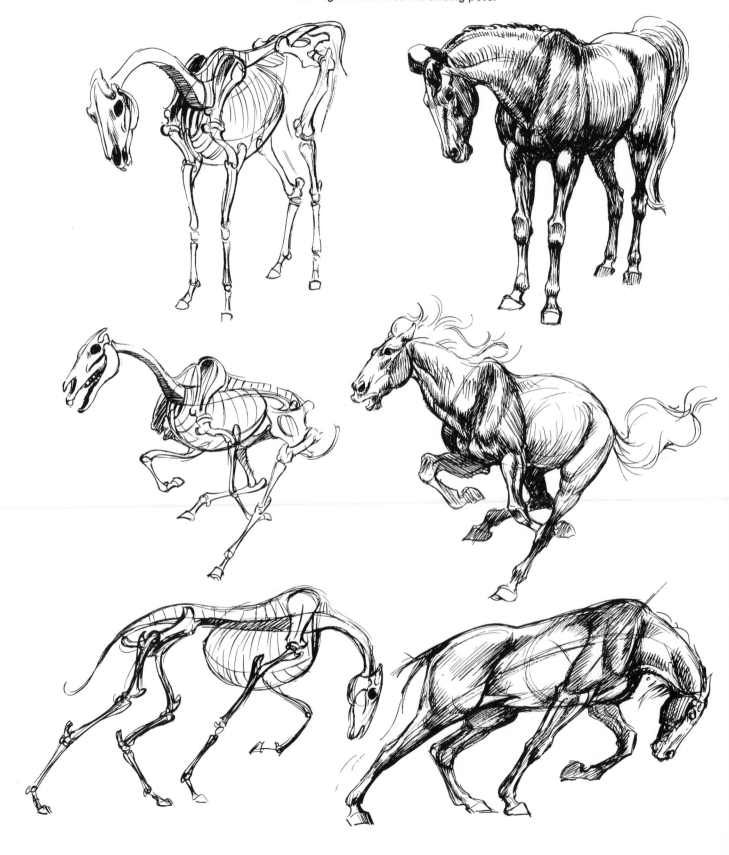

MUSCLE STRUCTURE

Note underlayer of muscles leading to head. It would be a good exercise to draw in the skeleton over this drawing, since it would show clearly where the muscles wrap around various bones.

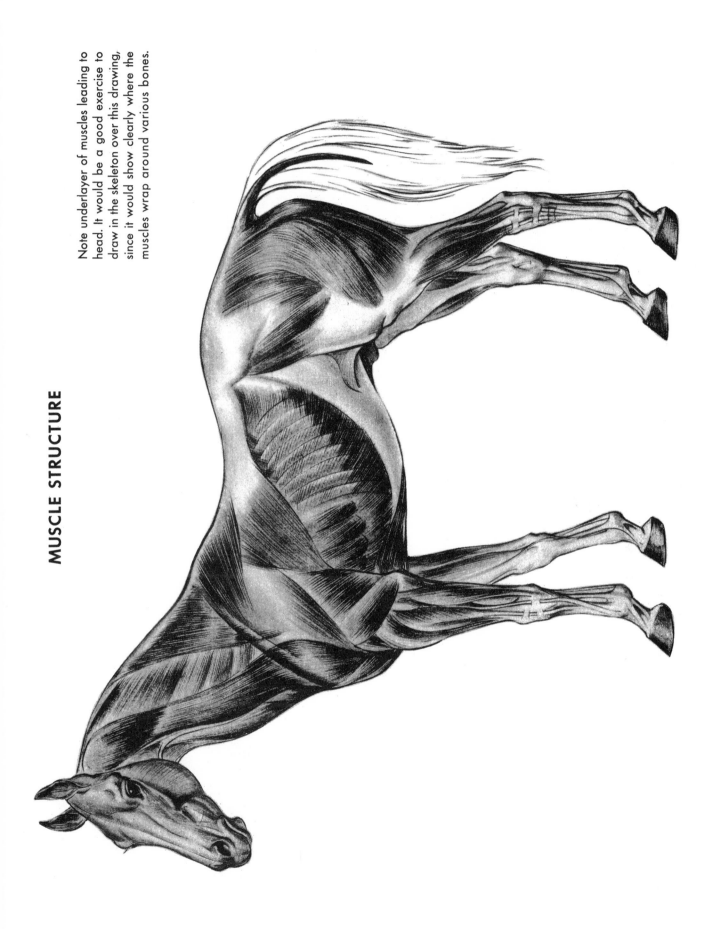

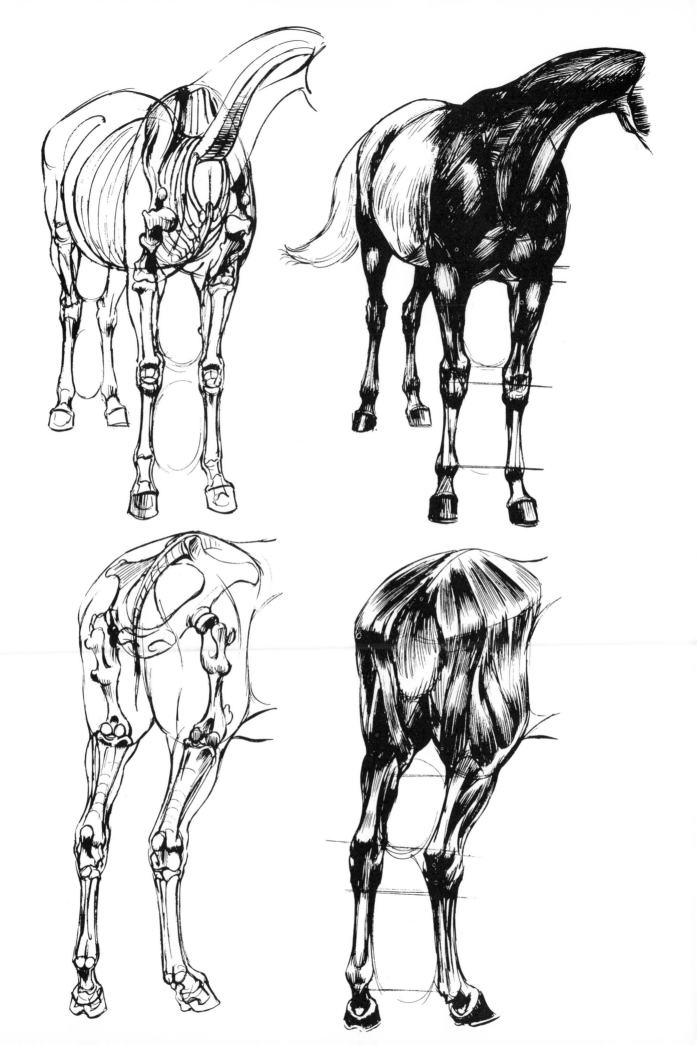

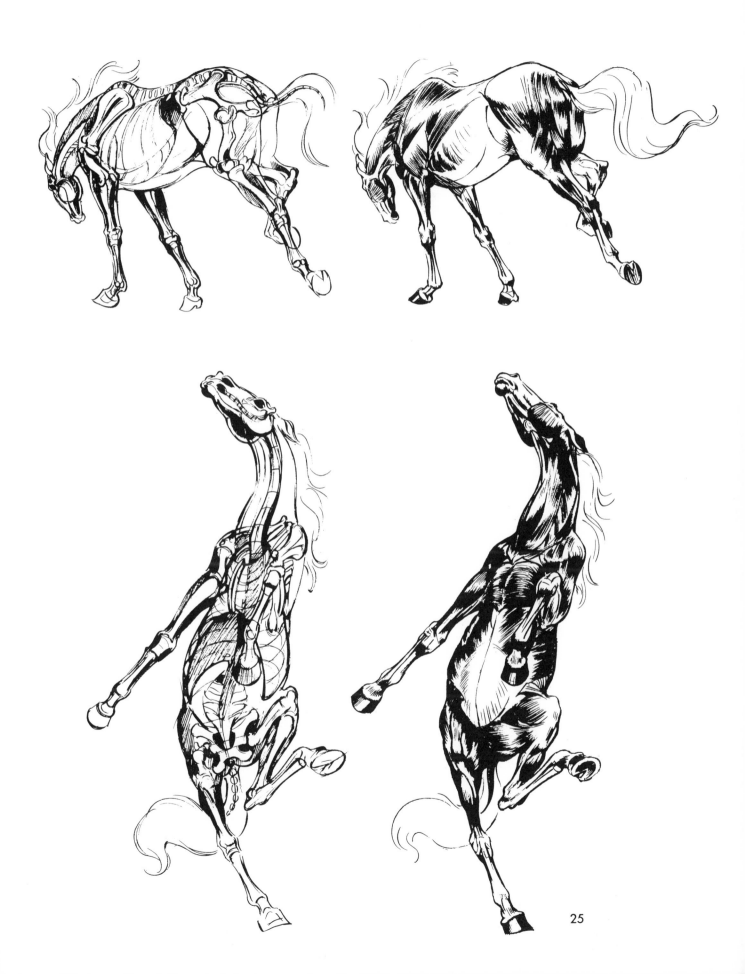

25

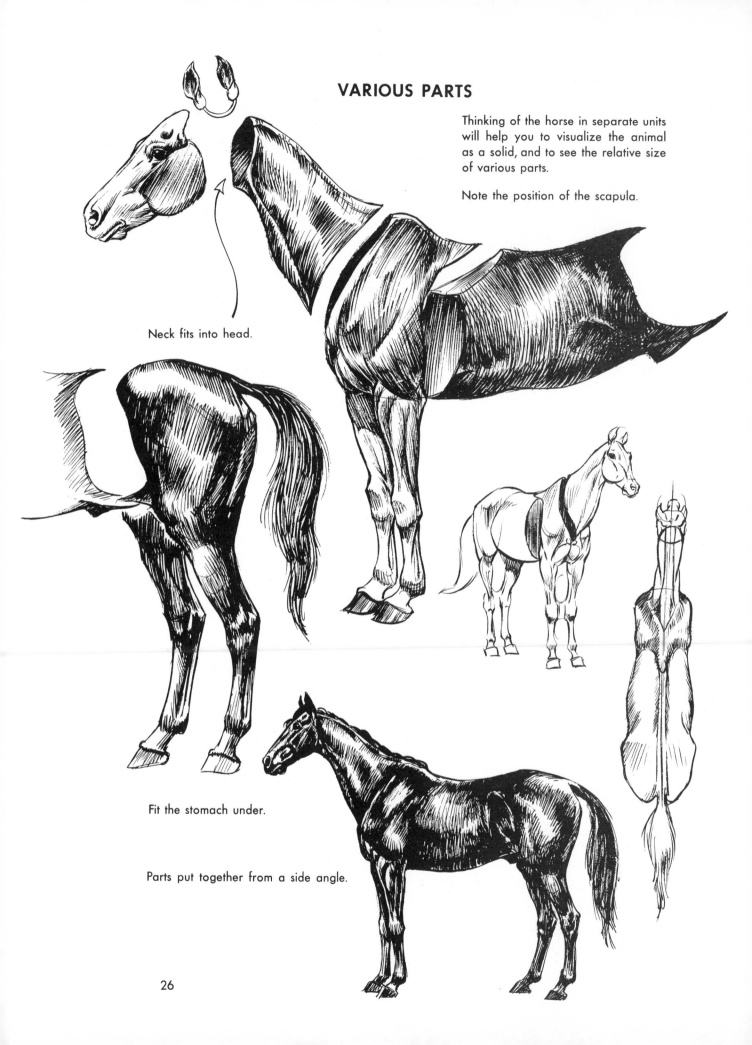

VARIOUS PARTS

Thinking of the horse in separate units will help you to visualize the animal as a solid, and to see the relative size of various parts.

Note the position of the scapula.

Neck fits into head.

Fit the stomach under.

Parts put together from a side angle.

HEADS

There is no easy way to block in a horse's head, since there are so many planes to consider. Once you are familiar with the skull, the job will be relatively simple, especially since much of the bone structure of the head is very pronounced.

Thinking of the head in two sections may help you. In the lower right-hand sketch, note how both the neck muscle and the bone behind the eye follow around the ear.

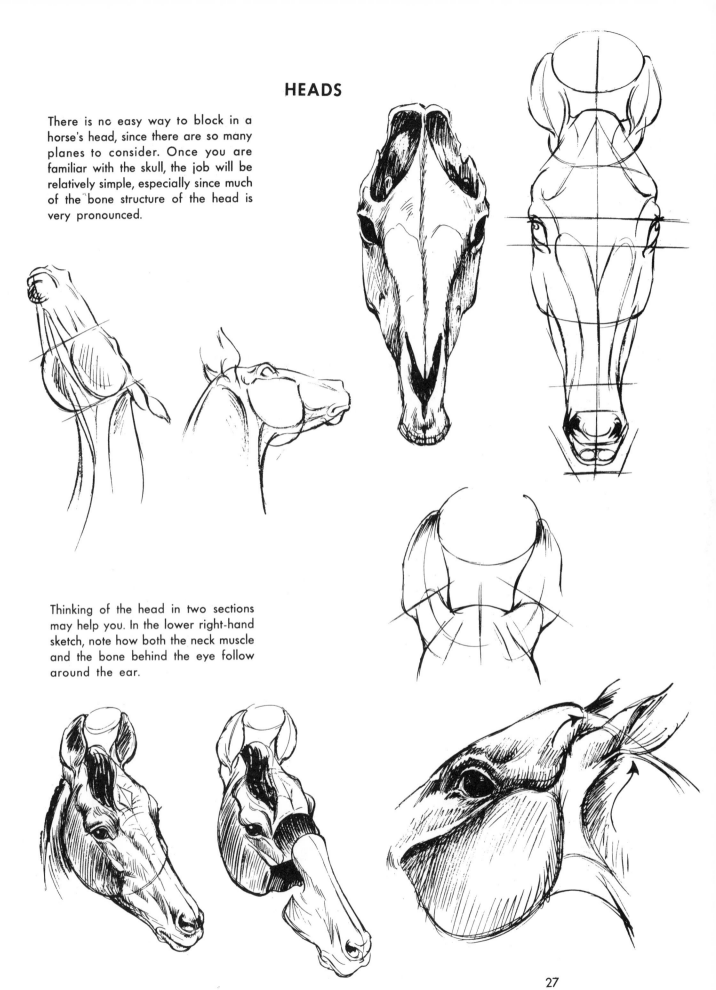

27

A common mistake of beginners is to place the eye of the horse too far forward. When roughing in the head, check the divisions to be sure it is in proper perspective.

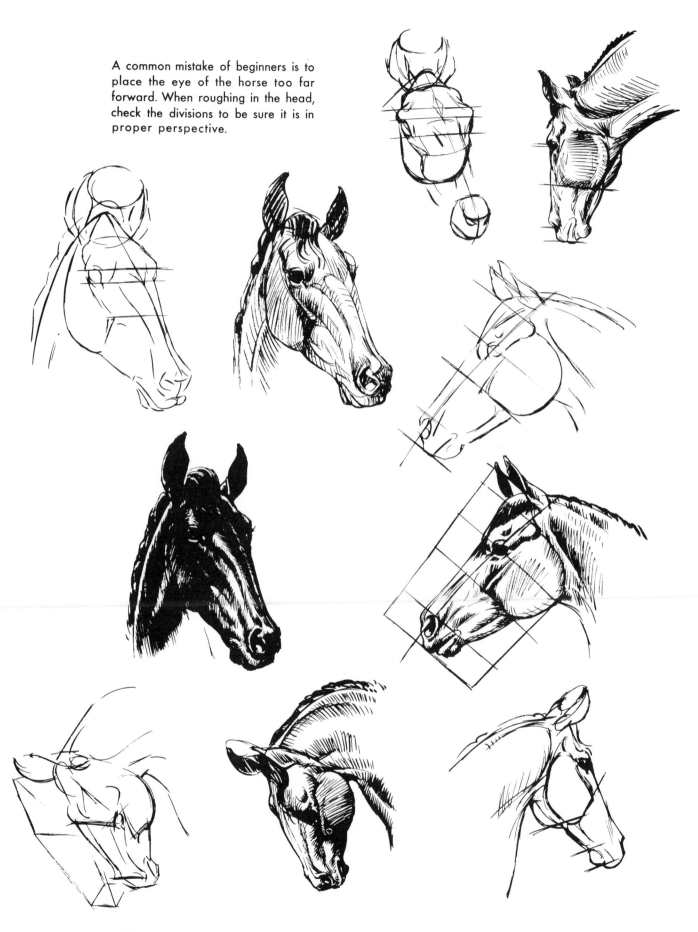

MUSCLE ACTION

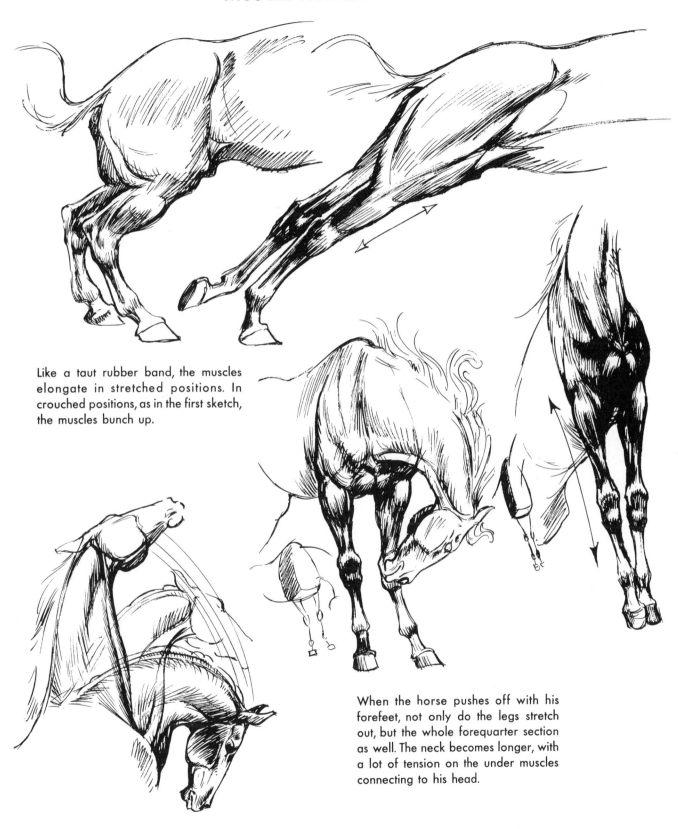

Like a taut rubber band, the muscles elongate in stretched positions. In crouched positions, as in the first sketch, the muscles bunch up.

When the horse pushes off with his forefeet, not only do the legs stretch out, but the whole forequarter section as well. The neck becomes longer, with a lot of tension on the under muscles connecting to his head.

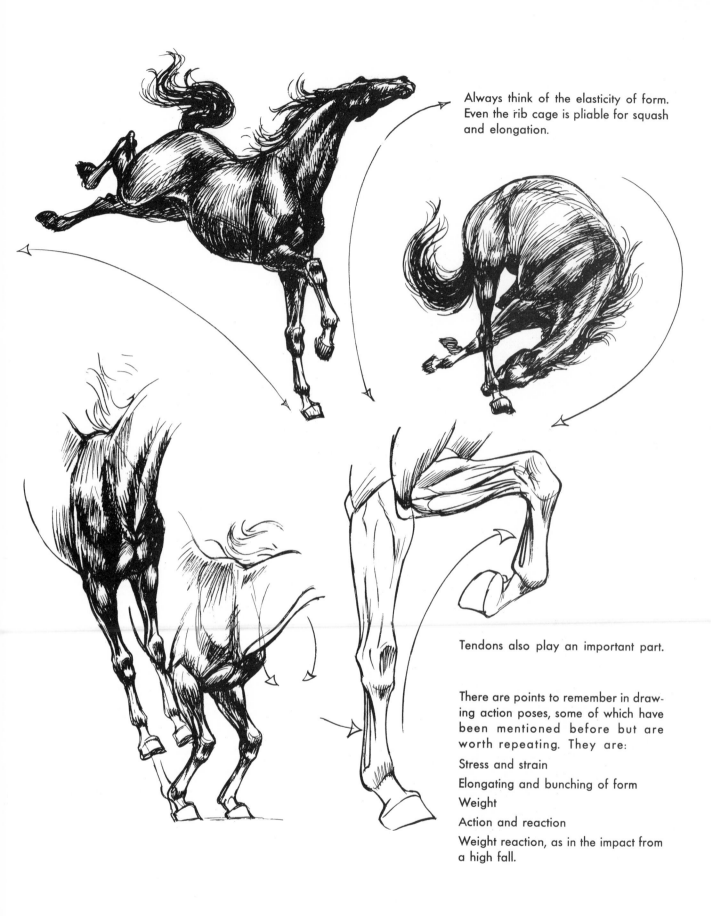

Always think of the elasticity of form. Even the rib cage is pliable for squash and elongation.

Tendons also play an important part.

There are points to remember in drawing action poses, some of which have been mentioned before but are worth repeating. They are:

Stress and strain

Elongating and bunching of form

Weight

Action and reaction

Weight reaction, as in the impact from a high fall.

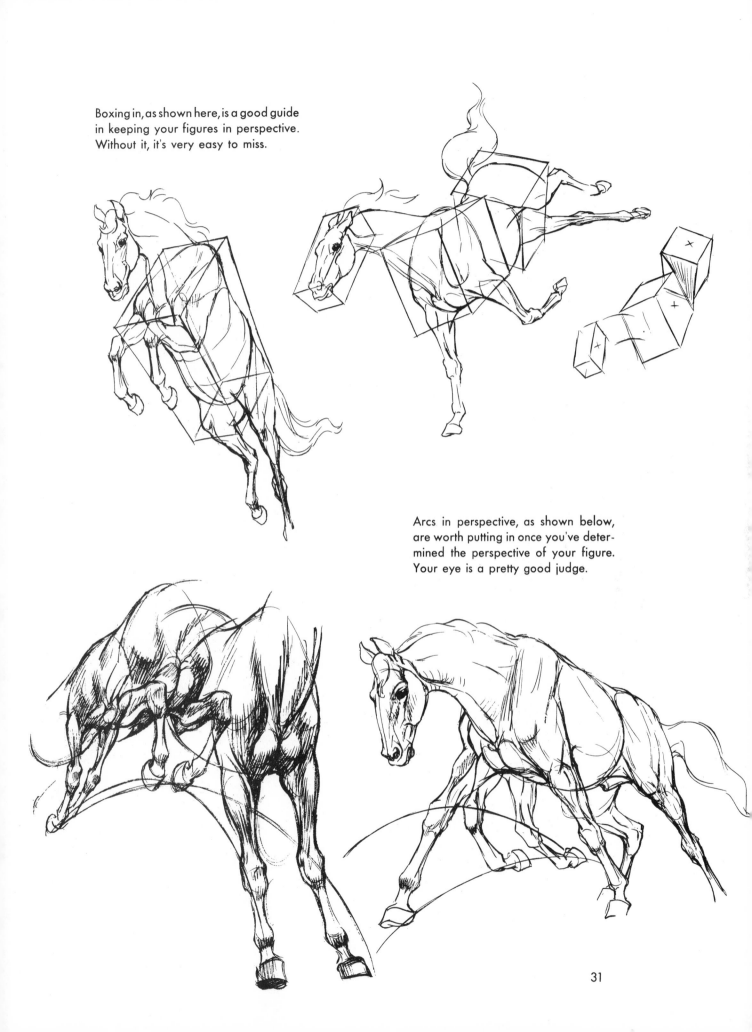

Boxing in, as shown here, is a good guide in keeping your figures in perspective. Without it, it's very easy to miss.

Arcs in perspective, as shown below, are worth putting in once you've determined the perspective of your figure. Your eye is a pretty good judge.

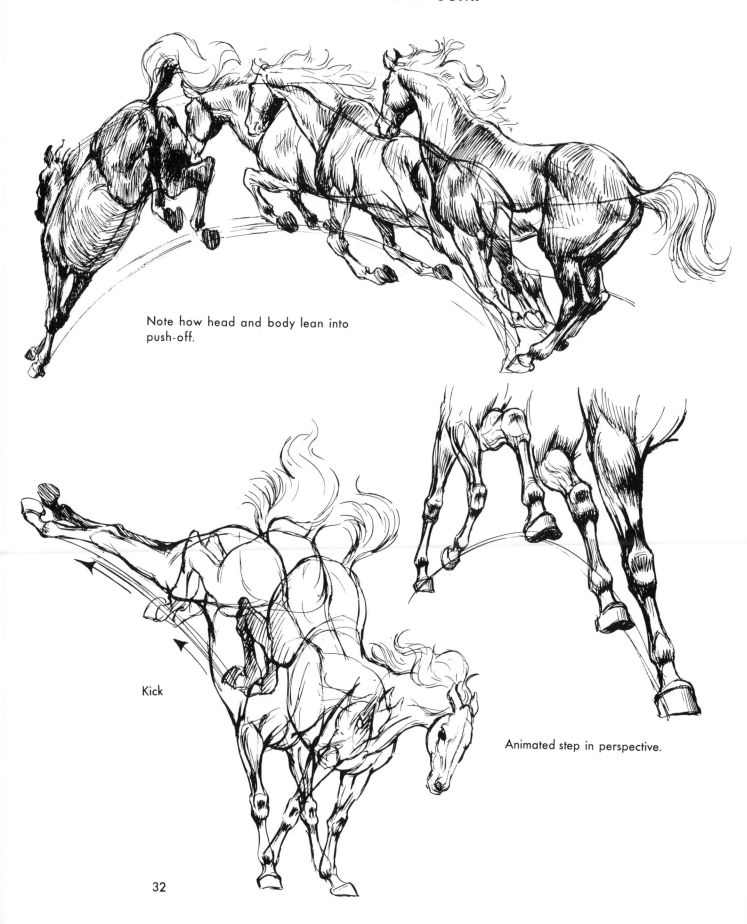

Note how head and body lean into push-off.

Kick

Animated step in perspective.

32

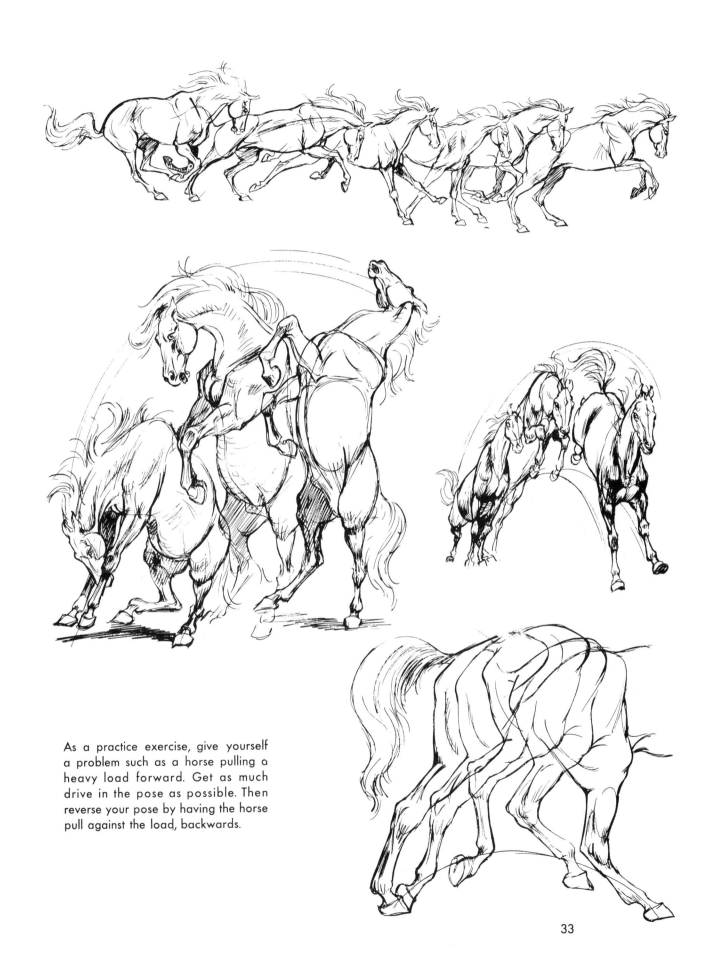

As a practice exercise, give yourself a problem such as a horse pulling a heavy load forward. Get as much drive in the pose as possible. Then reverse your pose by having the horse pull against the load, backwards.

33

TROT

A high-stepping, snappy action. Note that opposite legs work closely together (left foreleg, right hind leg).

CANTER

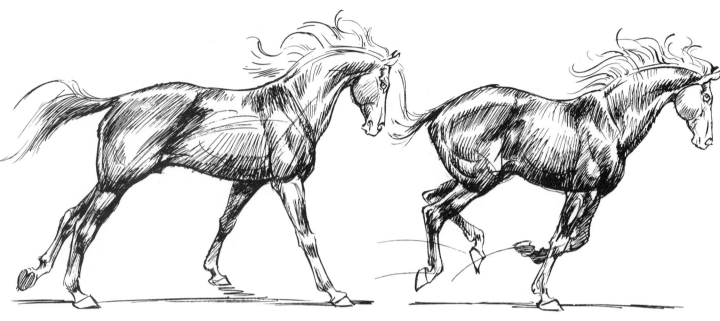

Right rear leg and left foreleg pushing
off, right foreleg taking weight.

Note dip of rear as legs pull through,
right foreleg pulling body.

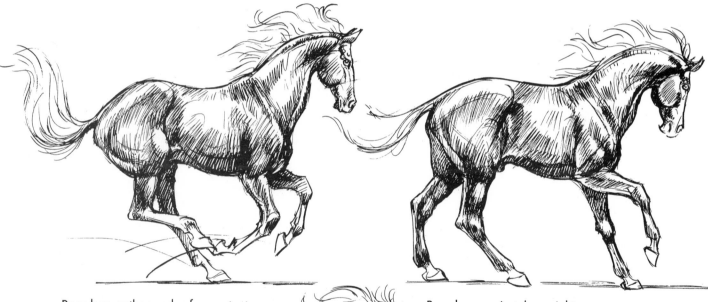

Rear legs gather under for contact.

Rear legs again take weight.

Back to beginning of cycle.

ROUGHING IN

Work for twists in the body as much as possible in action poses. Strive for variety in the leg action and reversal of forms.

Let your brush or pencil glide over the paper feeling the rhythm of the motion; forget detail; keep building.

At right, two stages of roughing in.

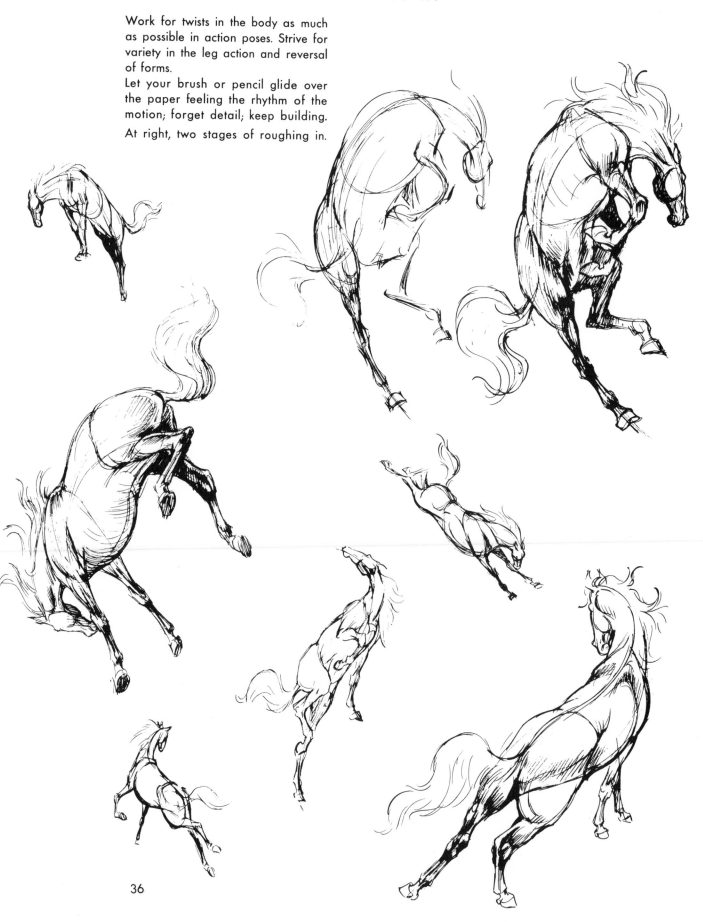

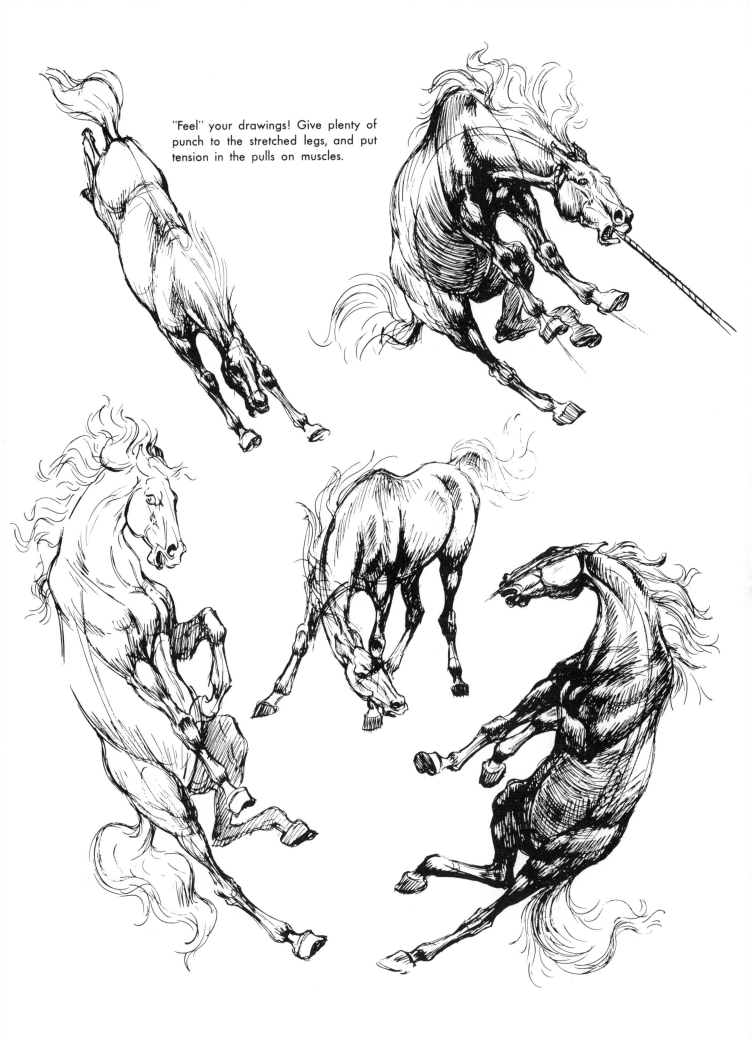

"Feel" your drawings! Give plenty of punch to the stretched legs, and put tension in the pulls on muscles.

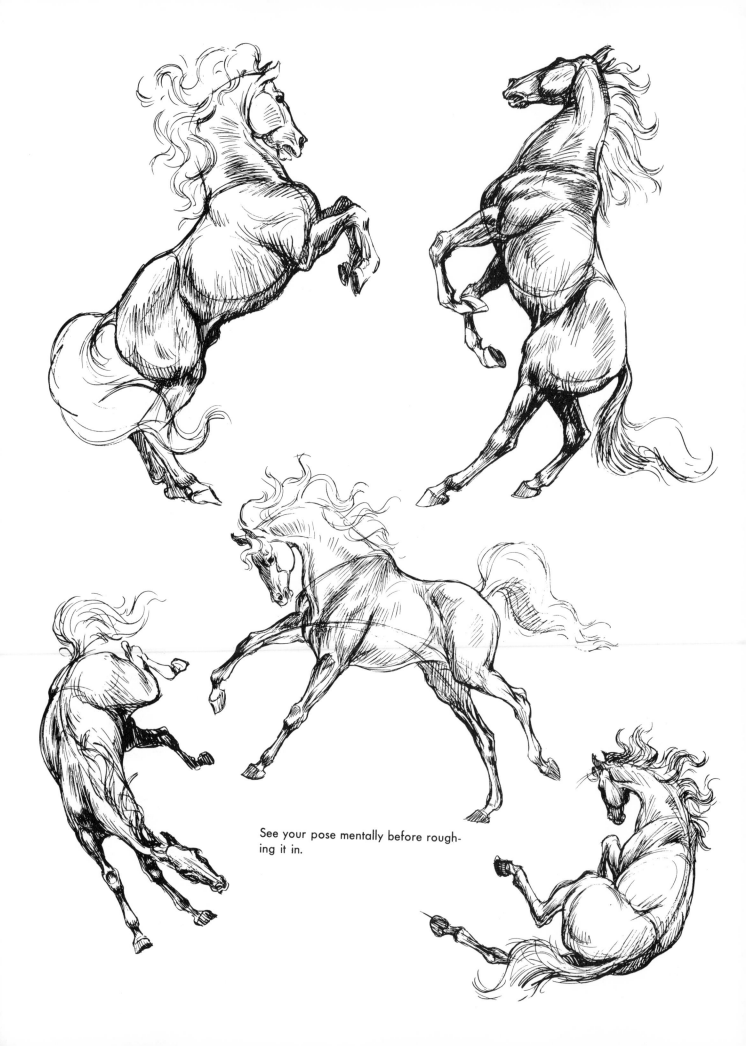

See your pose mentally before roughing it in.

DRAFT HORSES

These boxed-in drawings show the difference in size and conformation between the draft and saddle types of horse.

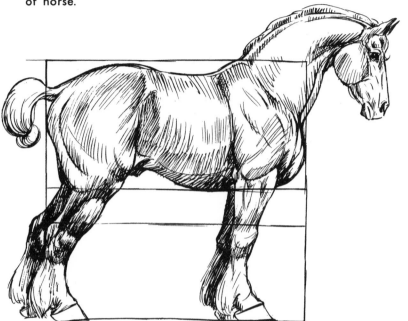

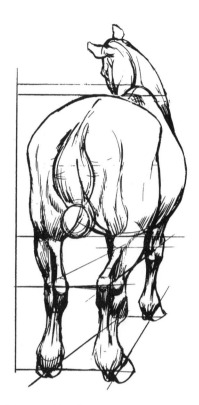

The draft horse is massive in neck and shoulders. For show purposes, the legs are feathered out.

Note width of rear.

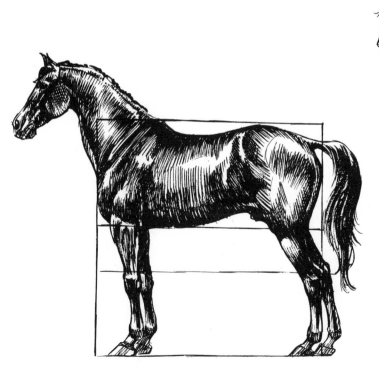

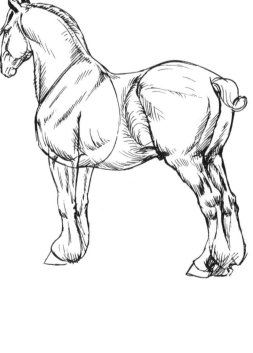

COLTS

Colts are very long-legged in proportion to the body. Note boxed-in figures for comparison. In drawing colts, keep in mind large joints on legs, small hoofs, slightly larger ears, short tail and mane, small muzzle, and slight dome of head.

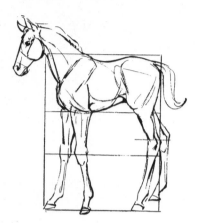

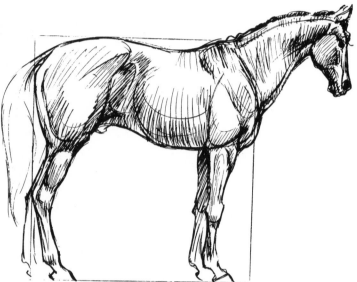

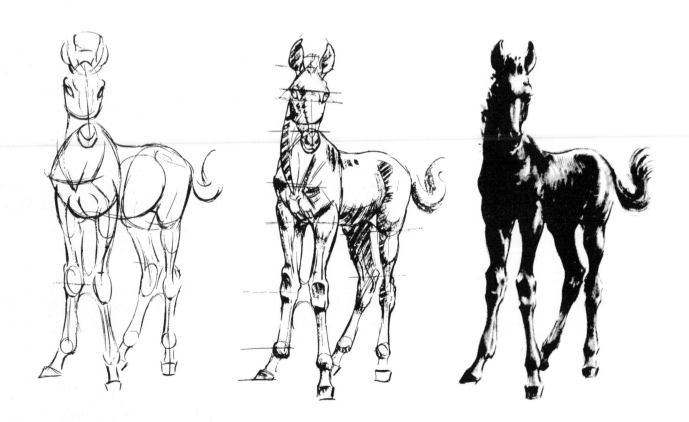

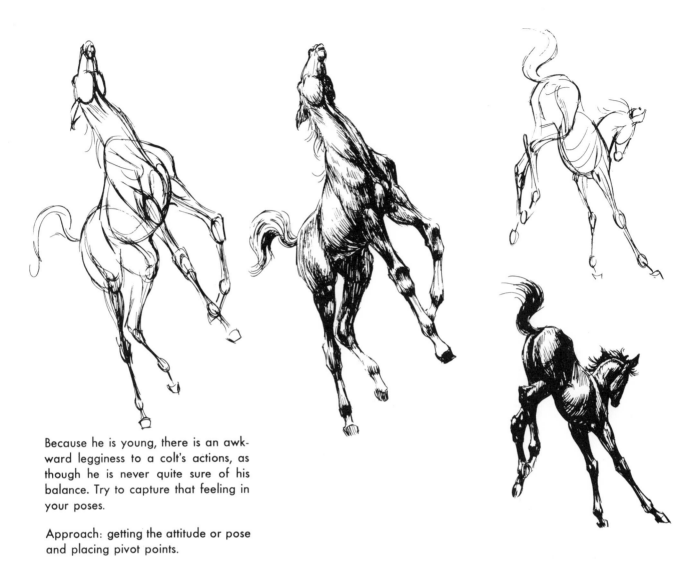

Because he is young, there is an awkward legginess to a colt's actions, as though he is never quite sure of his balance. Try to capture that feeling in your poses.

Approach: getting the attitude or pose and placing pivot points.

Feeling form — solidifying drawing.

Working in the detail of the forms.

BLOCKING IN

When you have your horses sketched in and you desire tone, block in your planes. Concentrate on basic planes first, and then work to the minor ones. When doing this, sketch in your lines following the contours of the body. If the basic planes are right, the lesser ones will not be difficult.

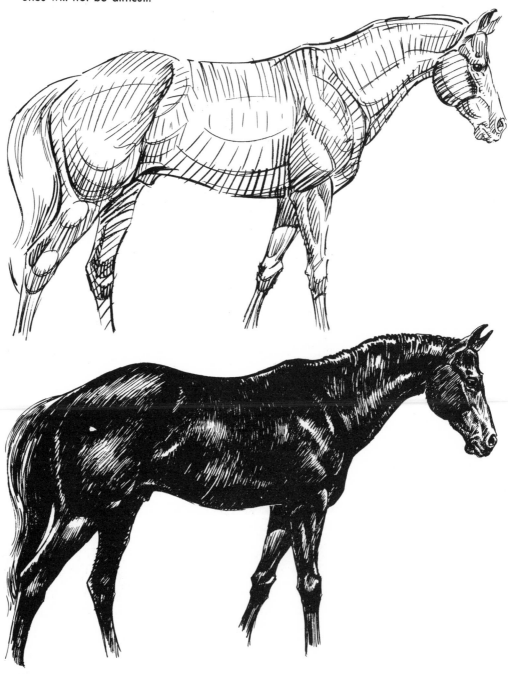

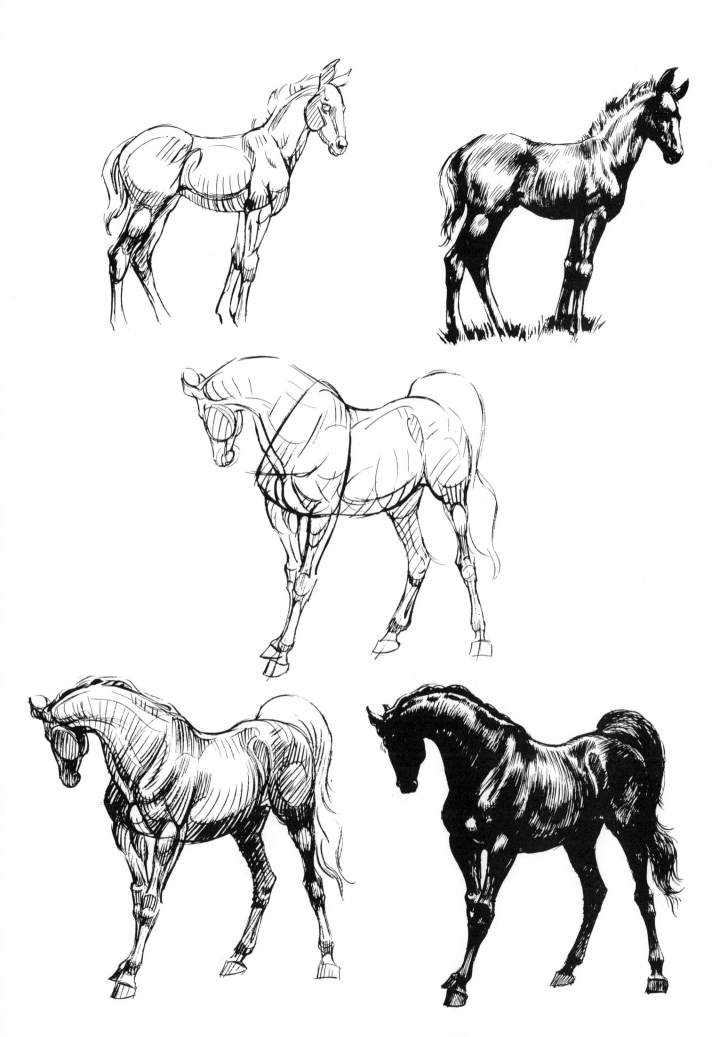

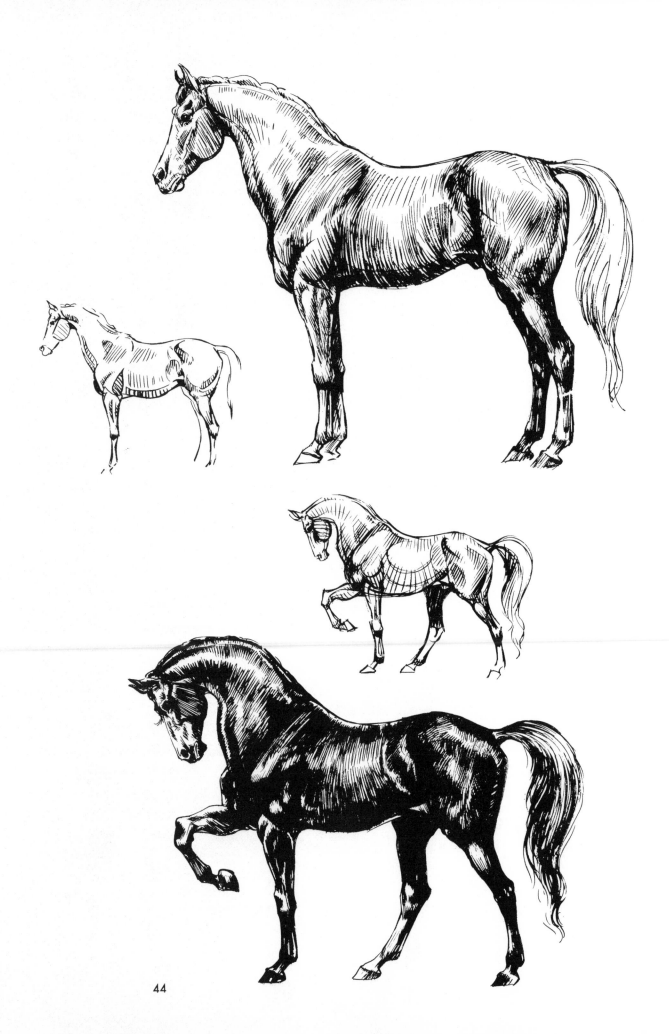

ZEBRAS

The zebra is a beautiful animal because of its design and markings.

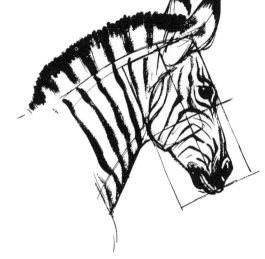

Note that the hind end is higher in proportion than that of the horse.

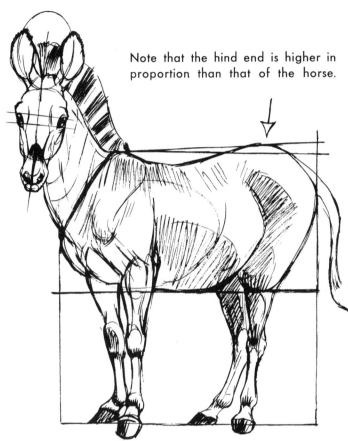

Characteristics of the zebra are large, round ears, short head, and, as a rule, smaller hoofs than the horse.

The drawing below was done purposely without outside construction lines, to show how the stripes follow the form of the animal.

Note larger stripes on rear.

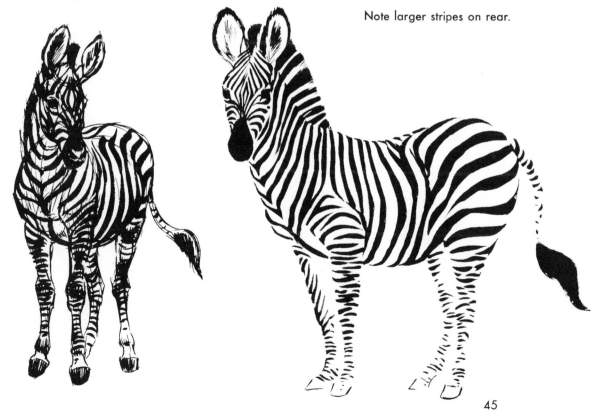

HORSES and ZEBRAS — CARICATURE

On the draft horse, exaggerate chest and try to keep an all-around short stoutness.

To me, the zebra suggests cuteness and decorativeness. The points of exaggeration are: large ears, small muzzle, short body, large rear, rather small, tapering legs, and small feet. The end of the tail is full and bushy.

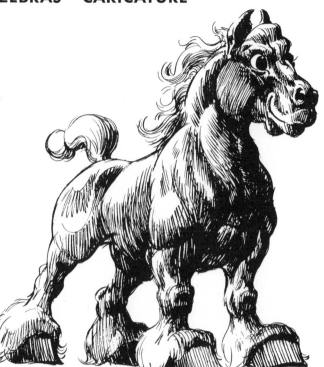

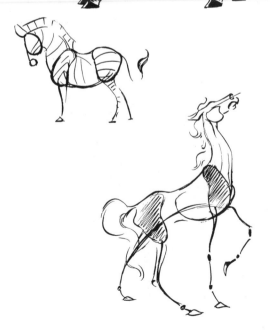

Note how small knees accent the fullness of feathering of the legs.

To suggest tall, sleek, aristocratic thoroughbred, all proportions have been kept slim and tapering.

Note flare given to tail for a peacock-like impression.

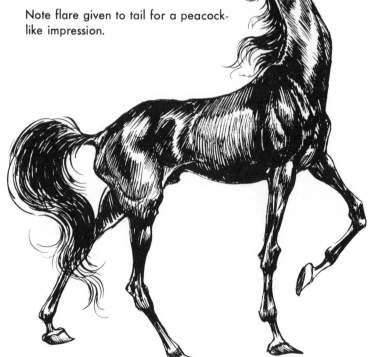

For a comic effect, I have used a
swayback, thin neck, large head, and
knock-knees with large hoofs.

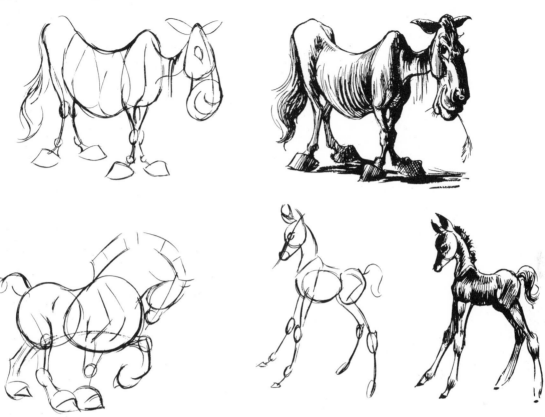

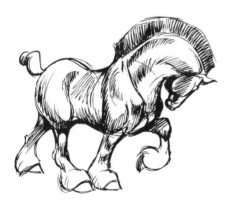

On the colt, I exaggerated the length
of the legs, the shortness of the body,
and the high crown and small muzzle.

The teeth have it in this one. Horses'
teeth do protrude at nearly a 45°
angle.

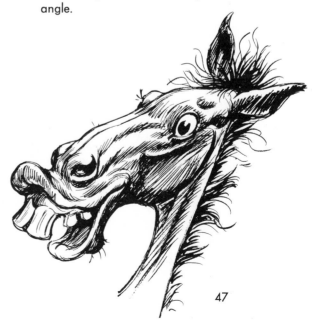

The Trojan mane accents the thick neck
of the draft horse. I slenderized his legs
to accentuate the fullness of the hoofs.

THE DEER FAMILY

The deer is slender, graceful, and angular in body. Work for tapering forms. The bone structure is very prominent in the legs.

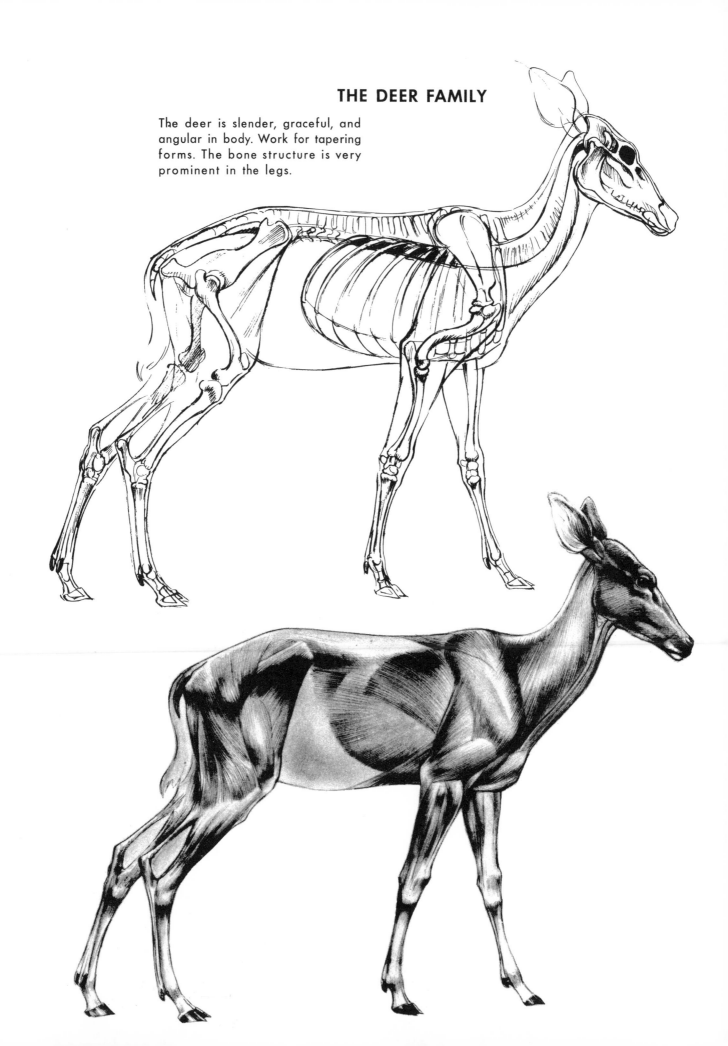

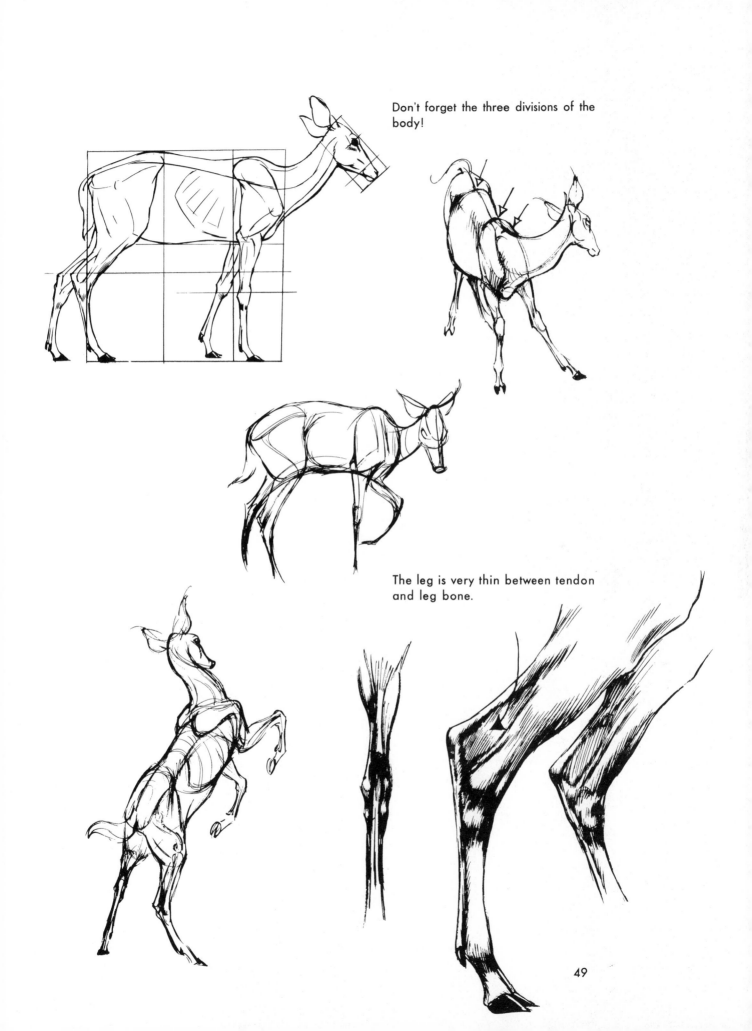

Don't forget the three divisions of the body!

The leg is very thin between tendon and leg bone.

49

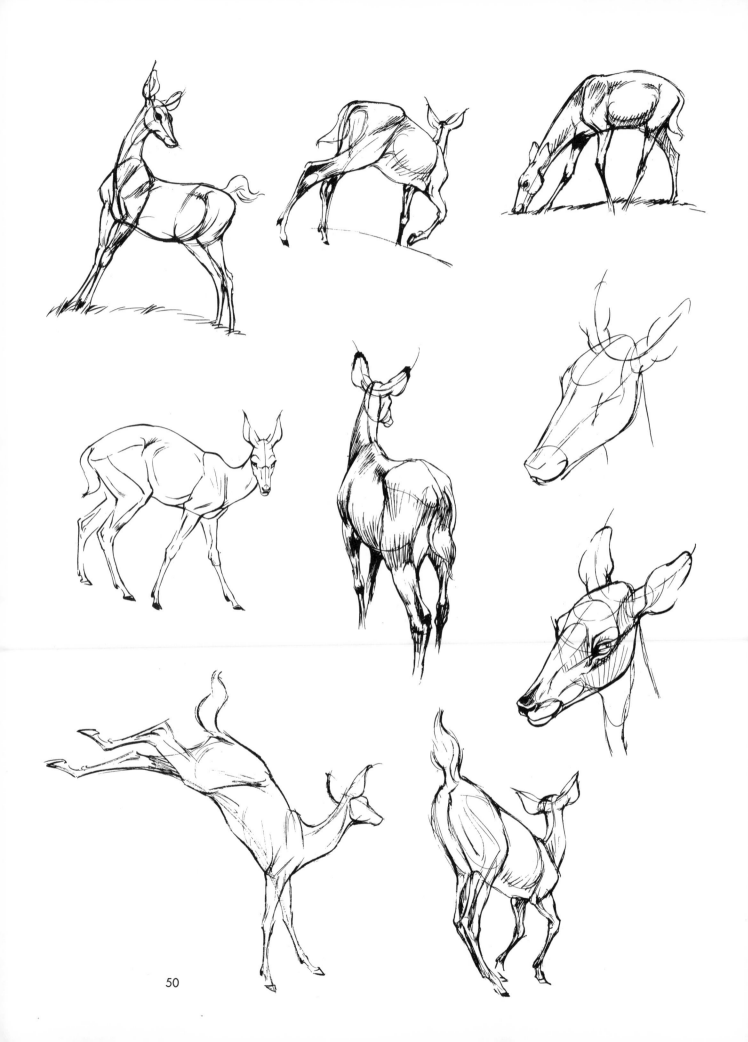

50

DEER—ANIMATION

Walk

Deer lift their feet high at the beginning of each step — note arcs.

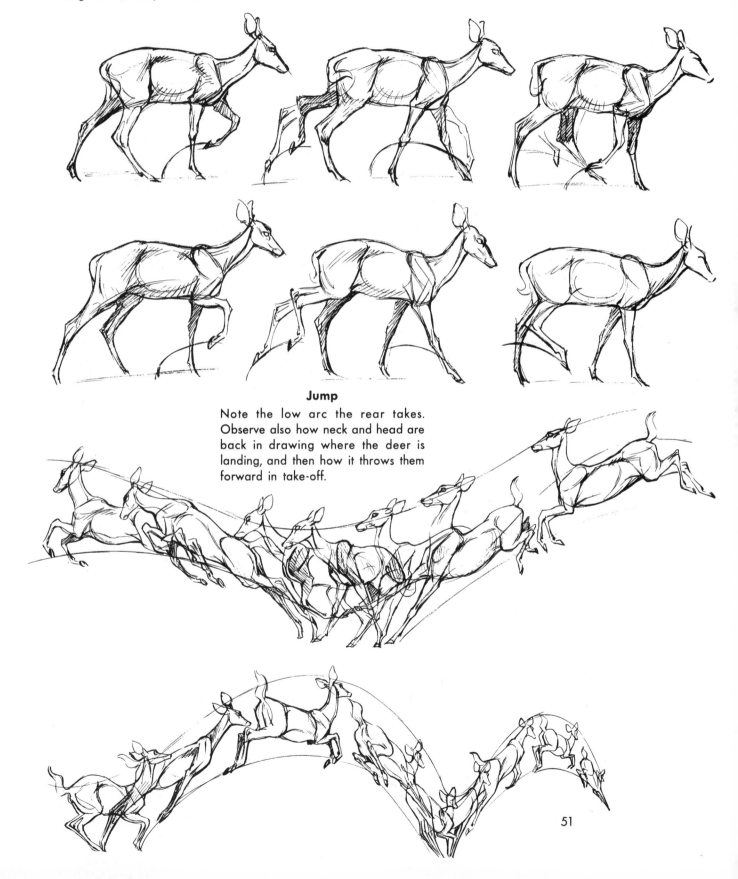

Jump

Note the low arc the rear takes. Observe also how neck and head are back in drawing where the deer is landing, and then how it throws them forward in take-off.

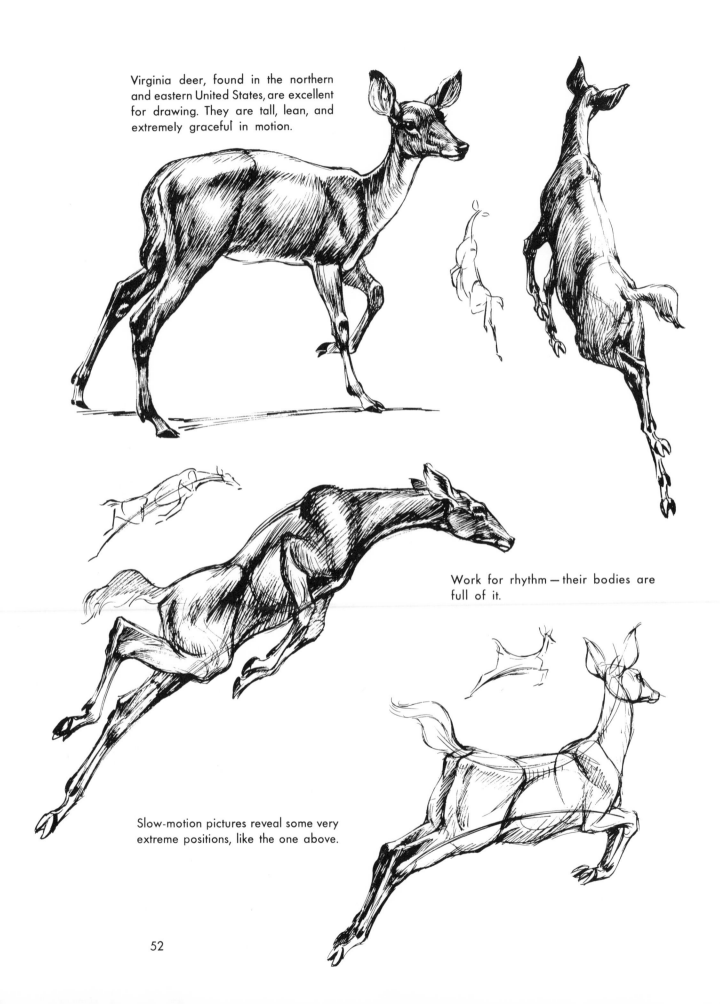

Virginia deer, found in the northern and eastern United States, are excellent for drawing. They are tall, lean, and extremely graceful in motion.

Work for rhythm — their bodies are full of it.

Slow-motion pictures reveal some very extreme positions, like the one above.

STAGS

The bone structure of the stag is naturally heavier than that of the doe. Its neck is thicker, the muscles are more pronounced, and it is broader generally throughout the body.

The antlers vary in size and number of prongs, in accordance with the age and type of deer. They furnish a nice decorative accent to the drawing.

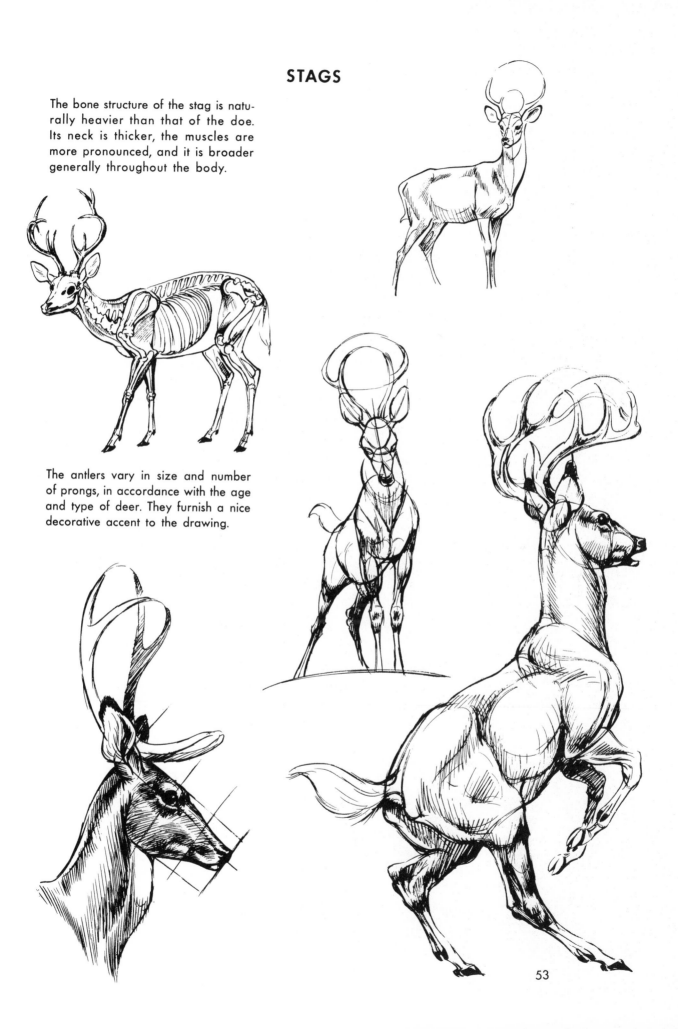

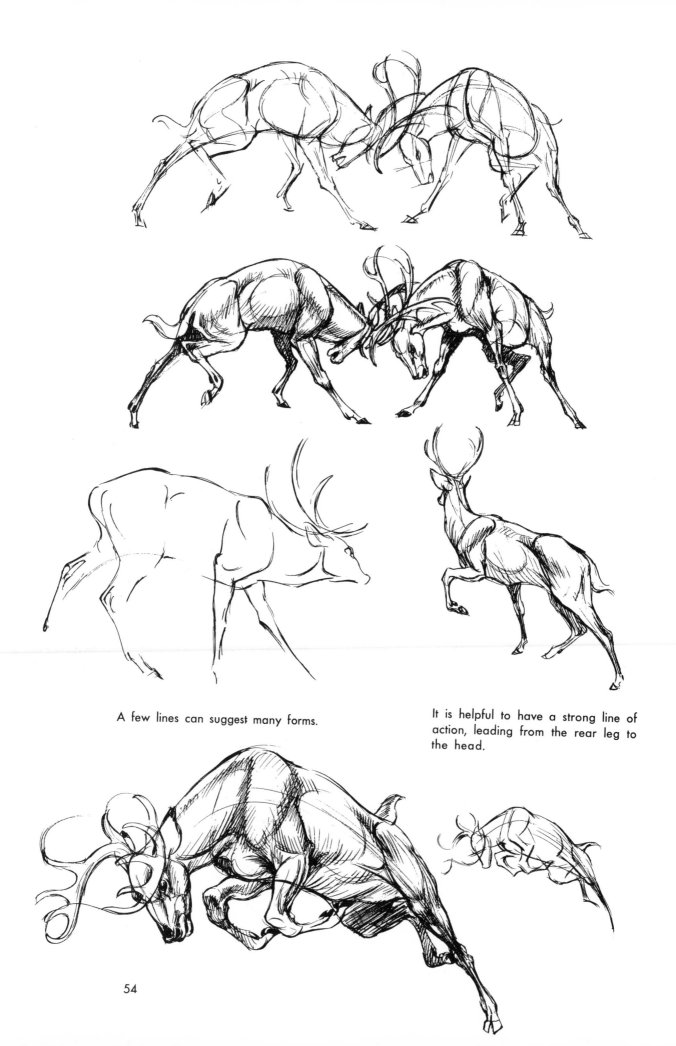

A few lines can suggest many forms.

It is helpful to have a strong line of action, leading from the rear leg to the head.

54

FAWNS

Fawns are very delicate in their bone structure. They are quite knock-kneed at an early age. Like most young animals, they have a high forehead.

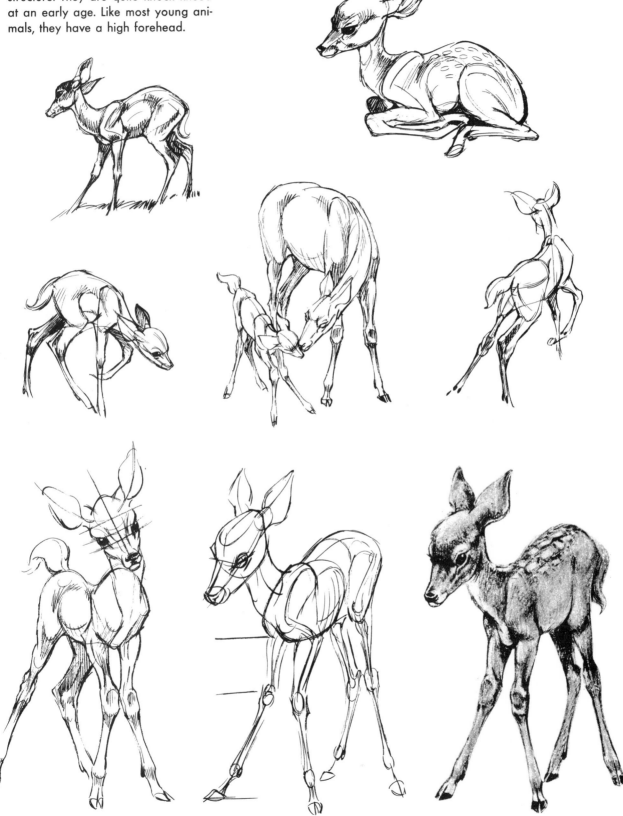

DEER—CARICATURE

Keep clean, sweeping lines, tapering body. In the adult, the arched neck contributes to the feeling of grace. For the fawn, emphasize the short body and long legs. Note how the crown is suggested.

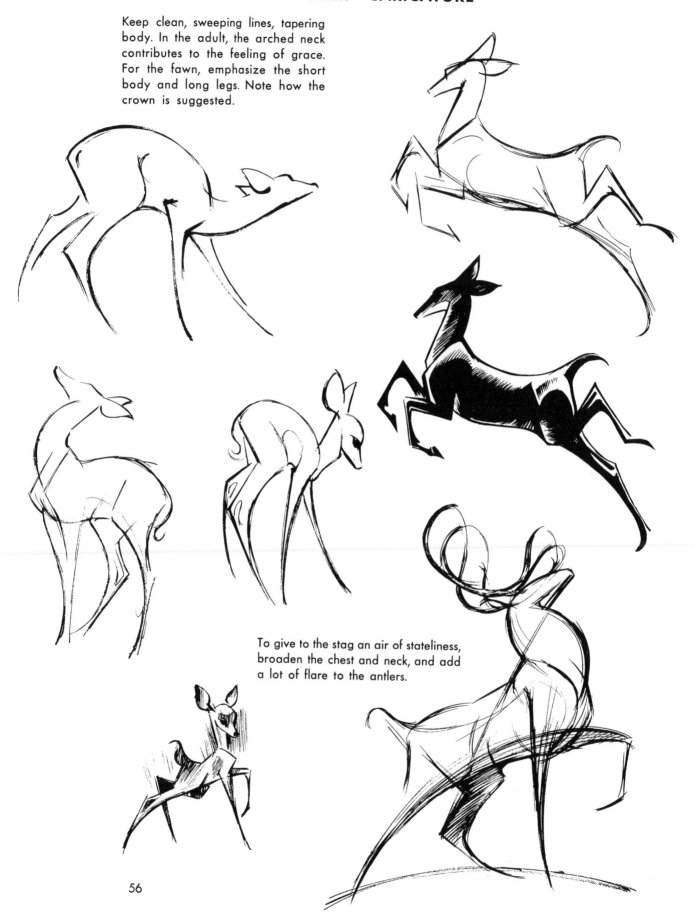

To give to the stag an air of stateliness, broaden the chest and neck, and add a lot of flare to the antlers.

THE CAT FAMILY

Generally, all cats are long and narrow in body, with long, tapering legs. The neck always appears to blend into the body in one graceful line.

To get rhythm in your cats, work for flow of line and tapering forms.

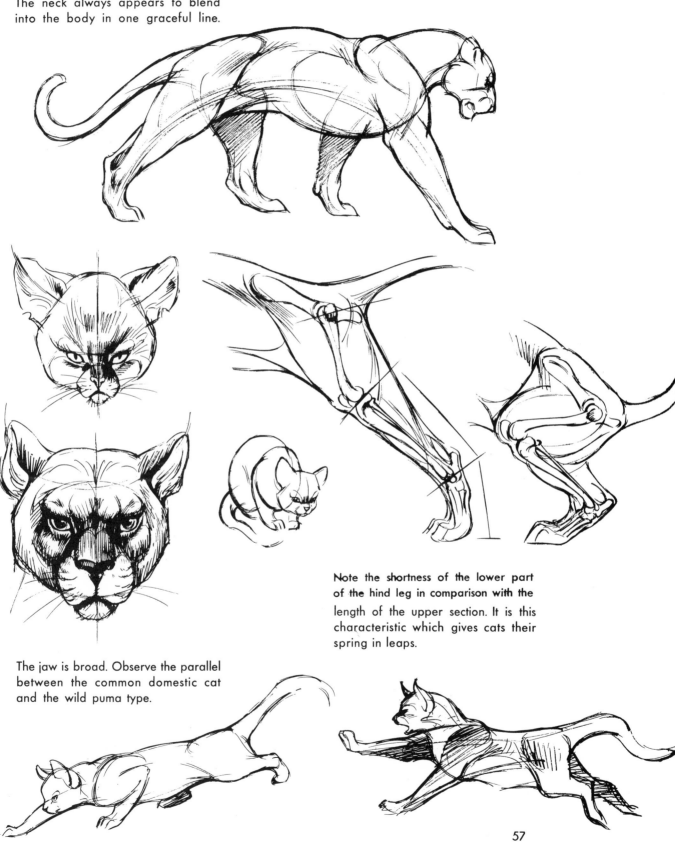

Note the shortness of the lower part of the hind leg in comparison with the length of the upper section. It is this characteristic which gives cats their spring in leaps.

The jaw is broad. Observe the parallel between the common domestic cat and the wild puma type.

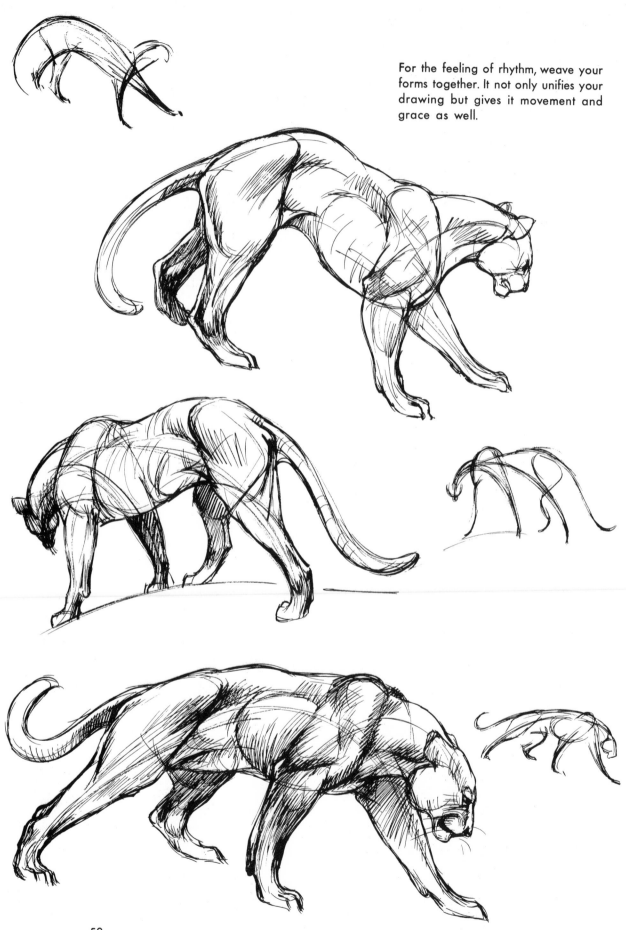

For the feeling of rhythm, weave your forms together. It not only unifies your drawing but gives it movement and grace as well.

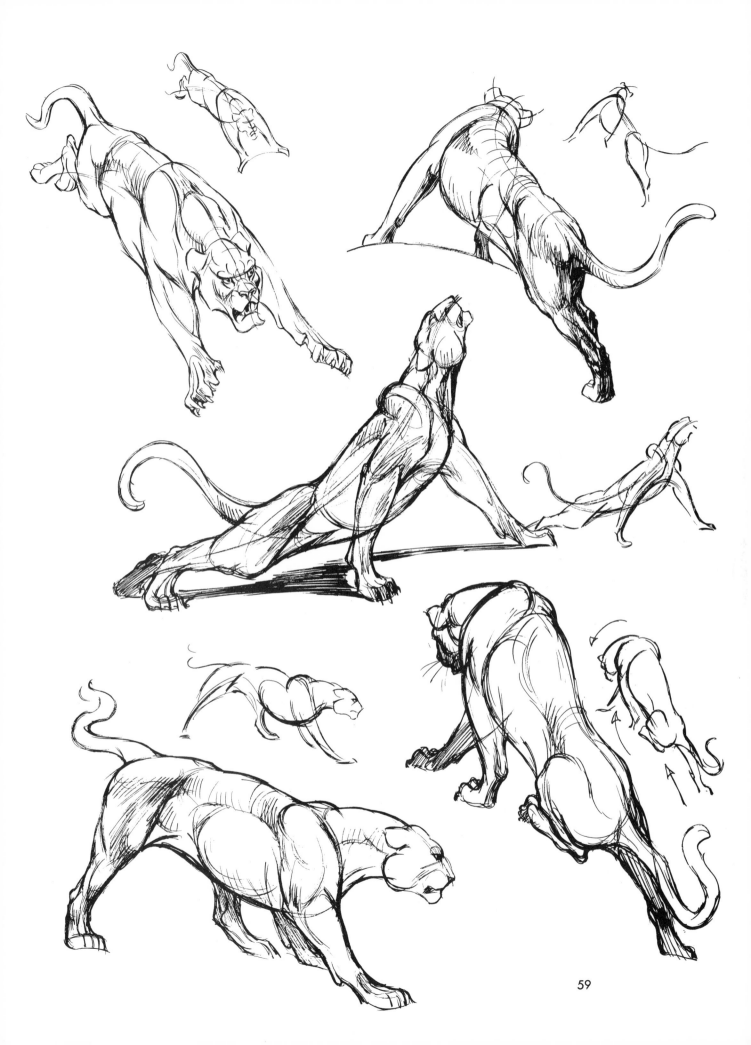

59

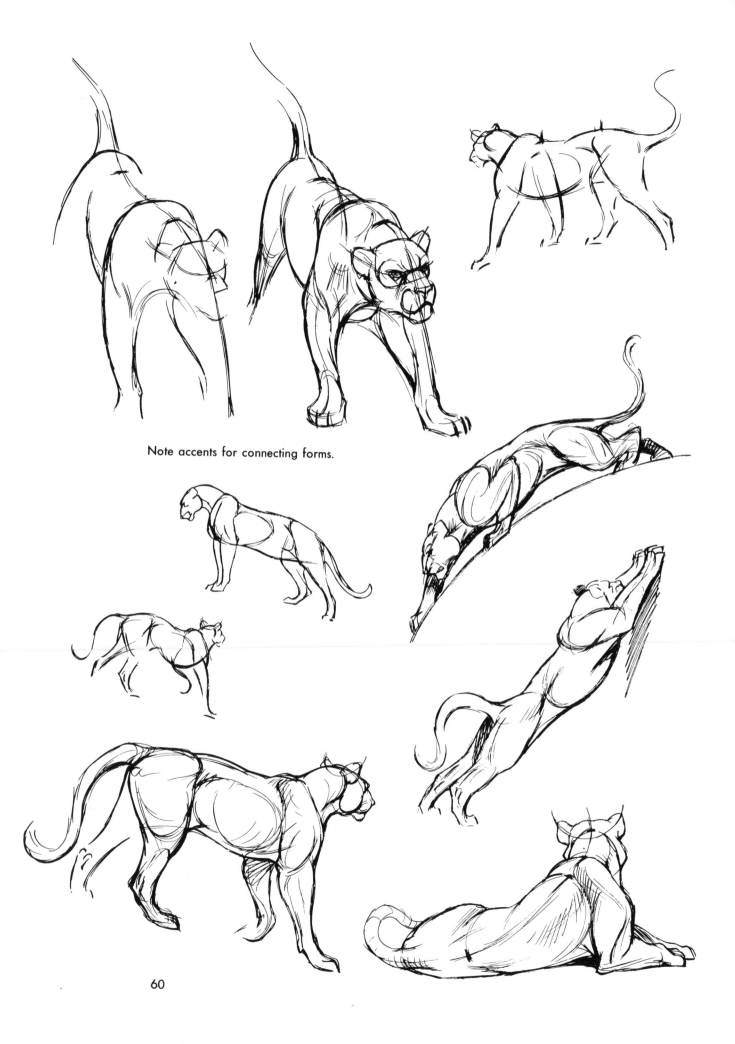

Note accents for connecting forms.

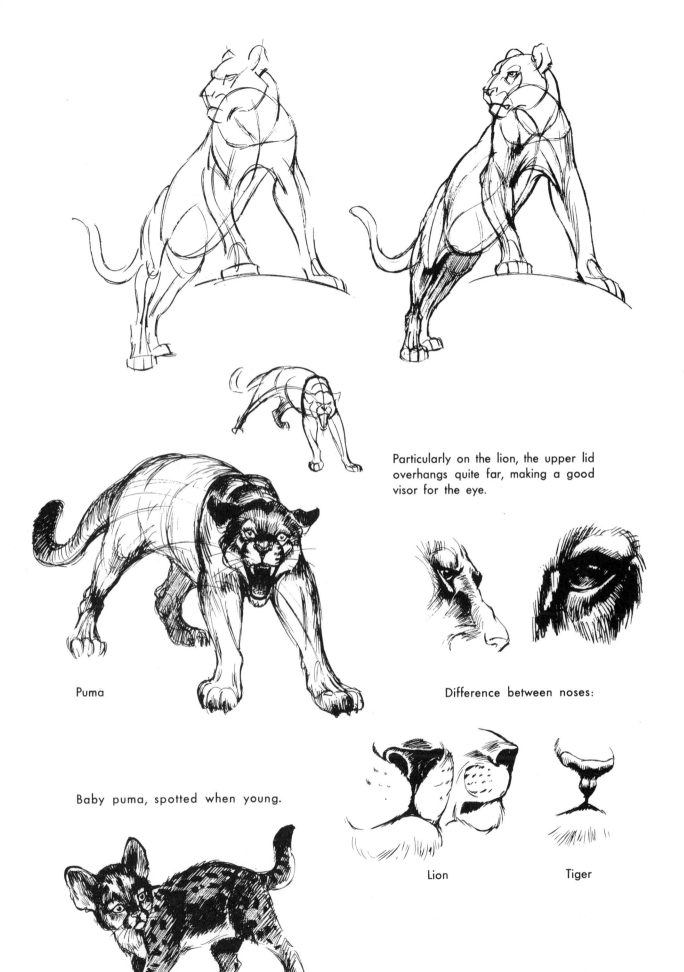

Particularly on the lion, the upper lid overhangs quite far, making a good visor for the eye.

Puma

Difference between noses:

Baby puma, spotted when young.

Lion

Tiger

LIONESS

The lioness is less broad than the male
and looks more graceful.

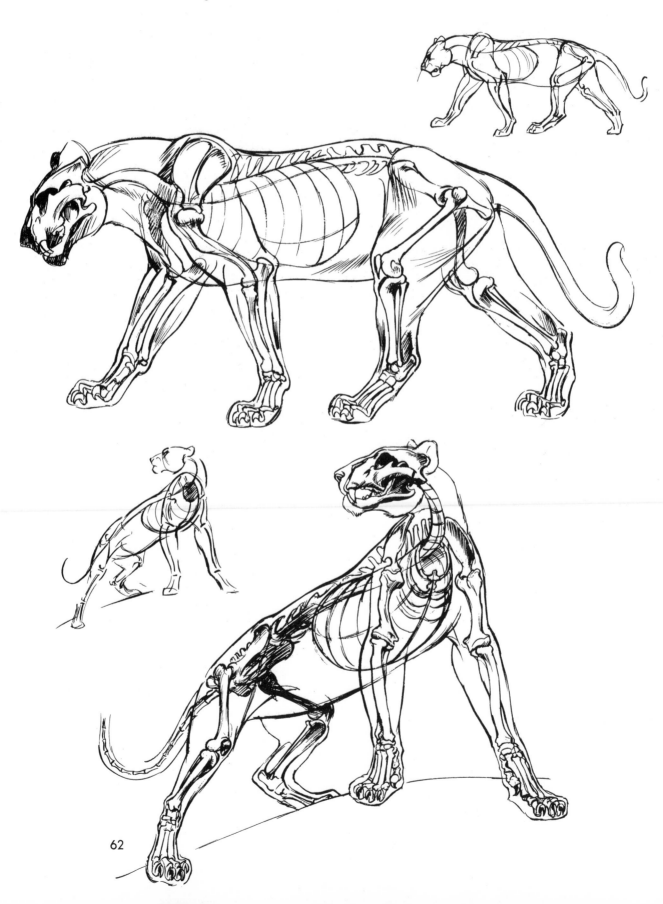

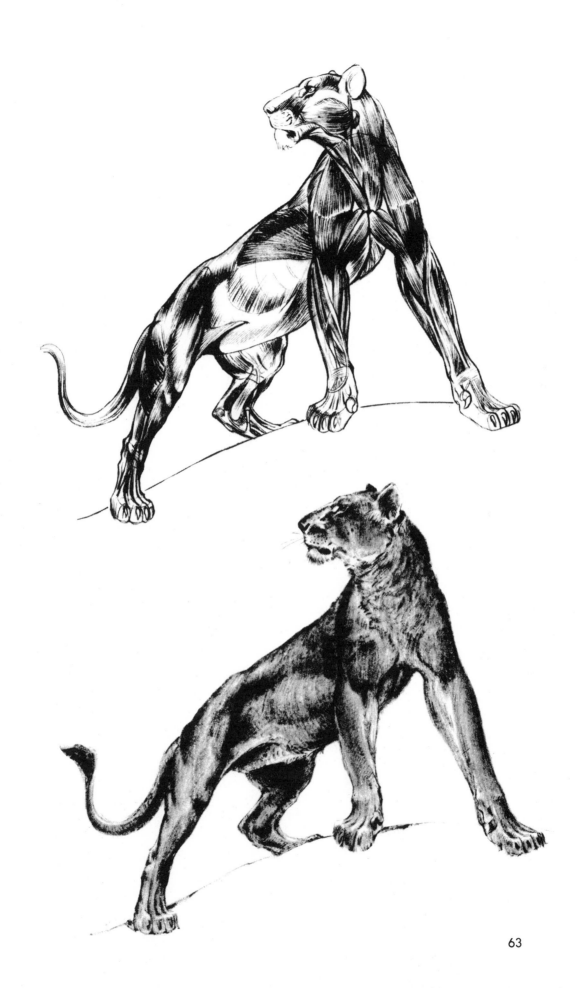

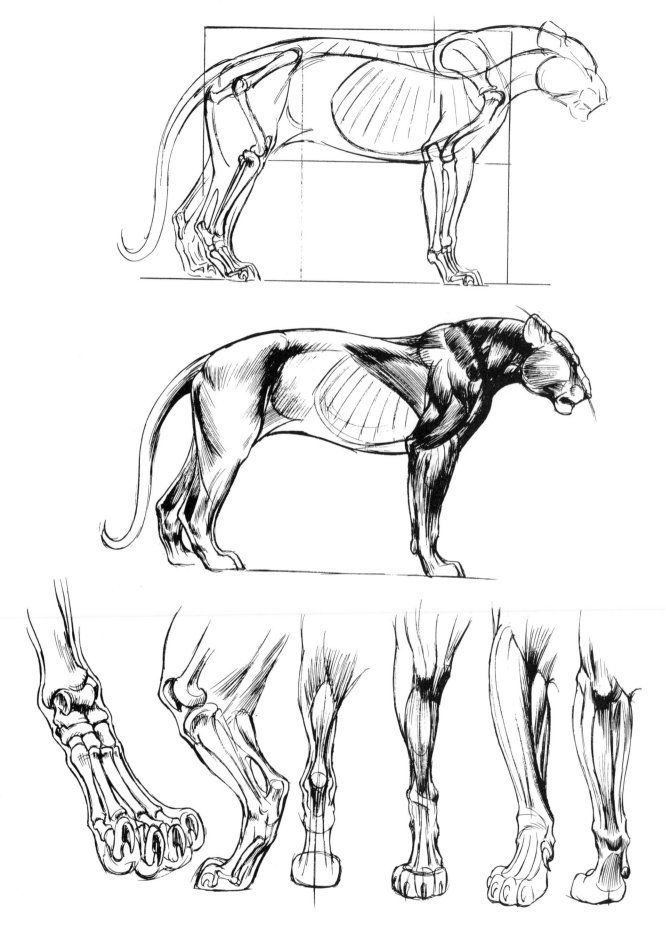

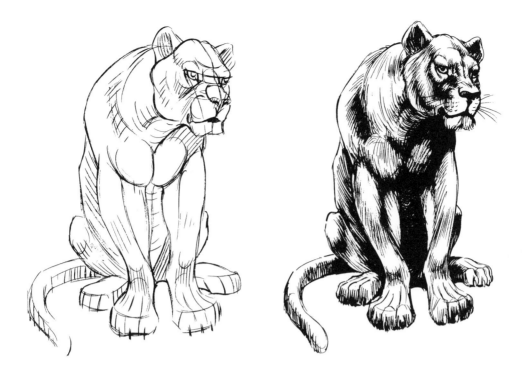

Head of Lioness

If the groundwork is right, the drawing will be solid.

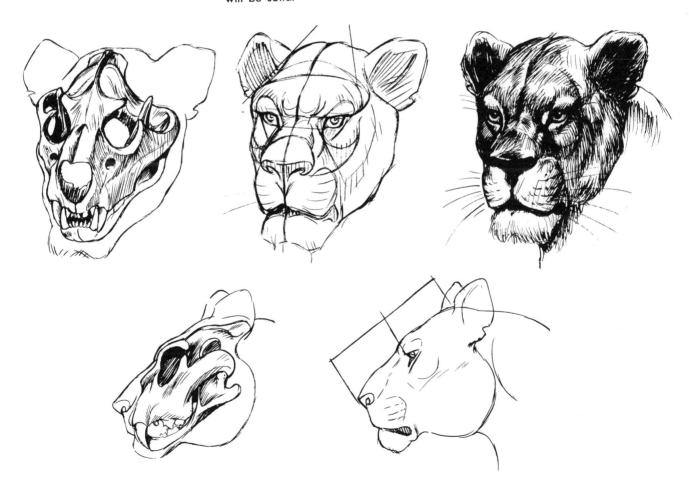

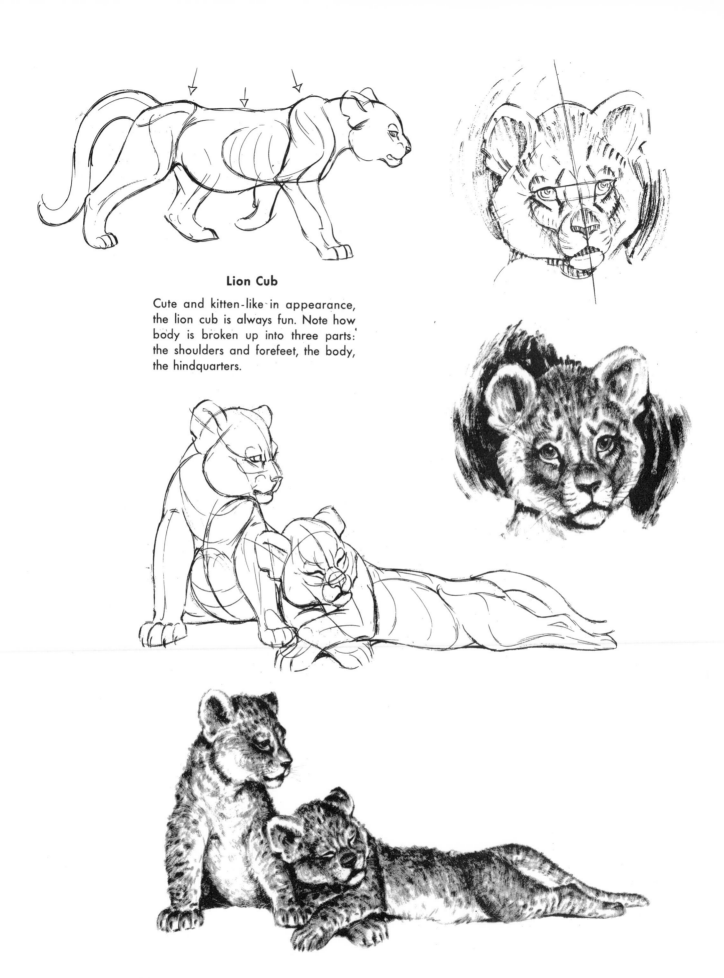

Lion Cub

Cute and kitten-like in appearance,
the lion cub is always fun. Note how
body is broken up into three parts:
the shoulders and forefeet, the body,
the hindquarters.

66

LION

The mane tapers back over the withers. On an adult lion, it also grows some distance back on the underside.

Because he is heavy and solid, the lion appears to be shorter-bodied than most cats.

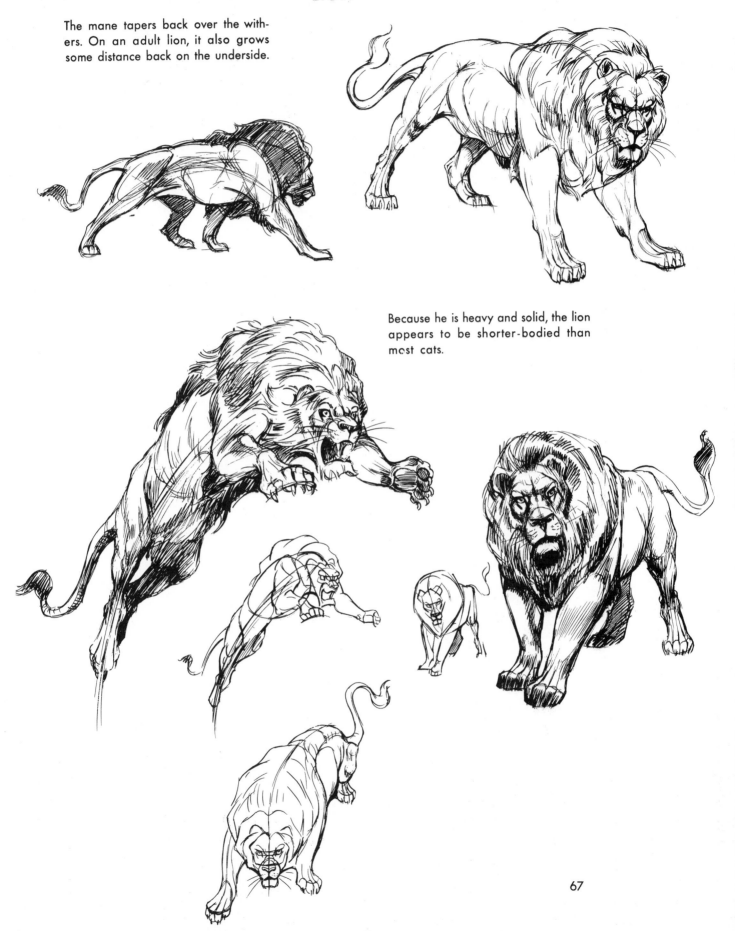

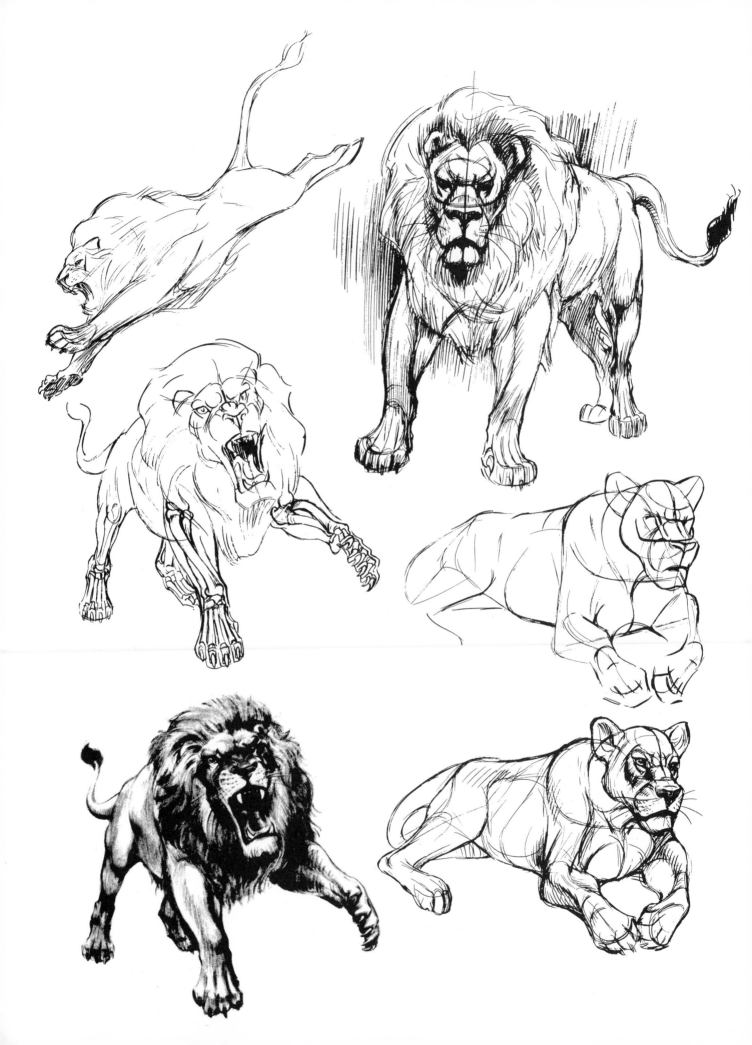

LION JUMP

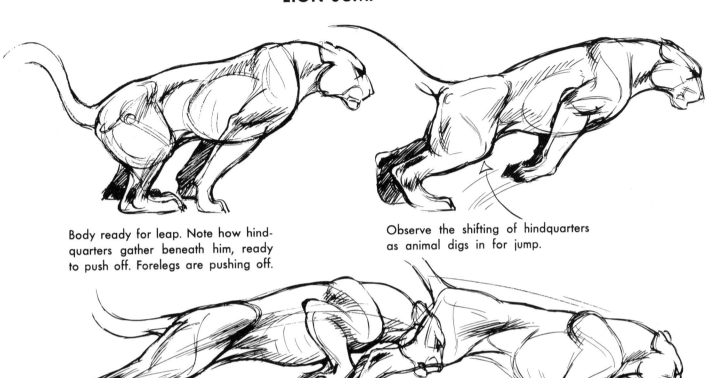

Body ready for leap. Note how hind-
quarters gather beneath him, ready
to push off. Forelegs are pushing off.

Observe the shifting of hindquarters
as animal digs in for jump.

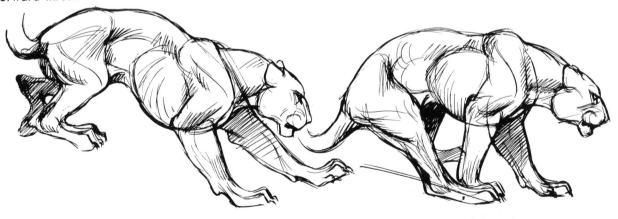

Body in push-off. Note strong line
of action through the whole body.
Forequarters draw close to body in
forward thrust.

Forelegs arch up, preparing to land.

Right foreleg takes weight in landing.
Left foreleg stretches for ground.
Hindquarters pull through from stretch
position.

Right hind leg stretches in landing. This
pose would lead into a pose similar
to number one if the cat were to jump
again.

BUILDING A HEAD

Work for broad planes at first. See
that your forms relate to each other.
Dividing the head down the middle
will help, since it will give you a line
of comparison by which to keep your
forms in proper perspective.

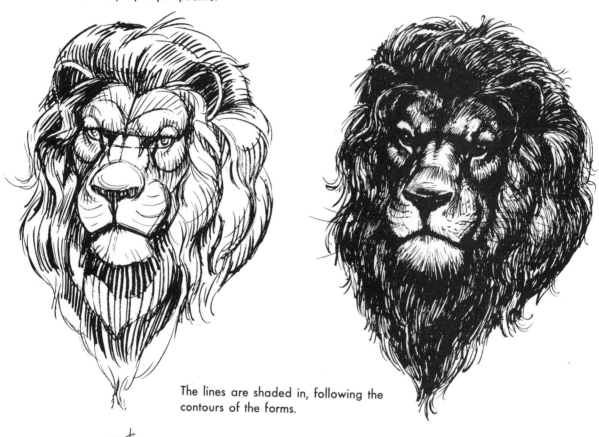

The lines are shaded in, following the
contours of the forms.

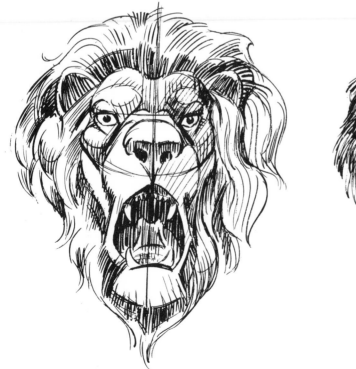

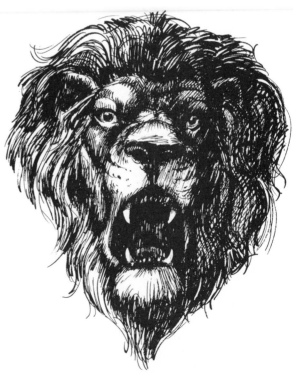

TIGER

The tiger is long in body, with a sturdy back. He has beautiful, tapering lines, and is pleasant to watch because of his gracefulness.

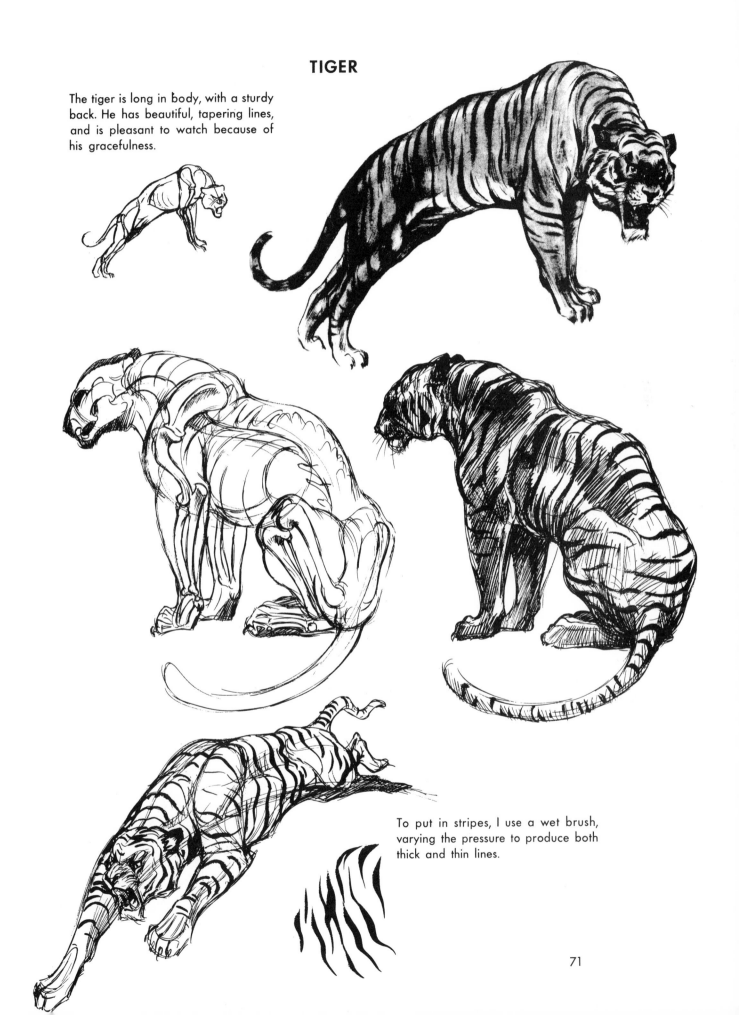

To put in stripes, I use a wet brush, varying the pressure to produce both thick and thin lines.

71

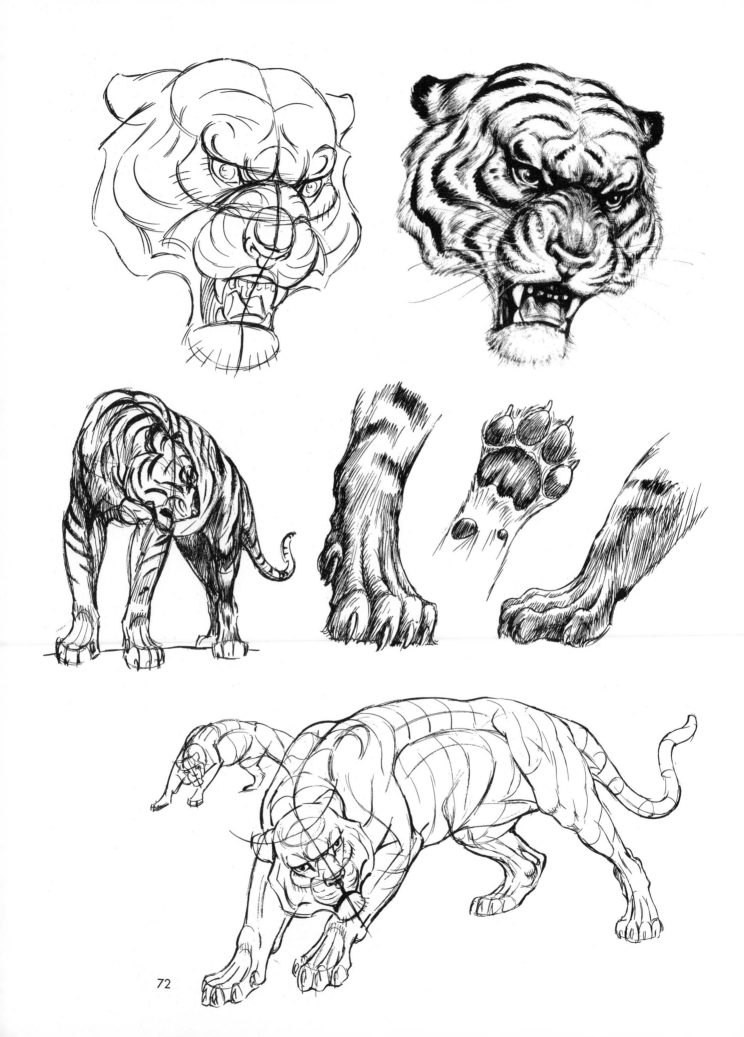

72

DOMESTIC CATS

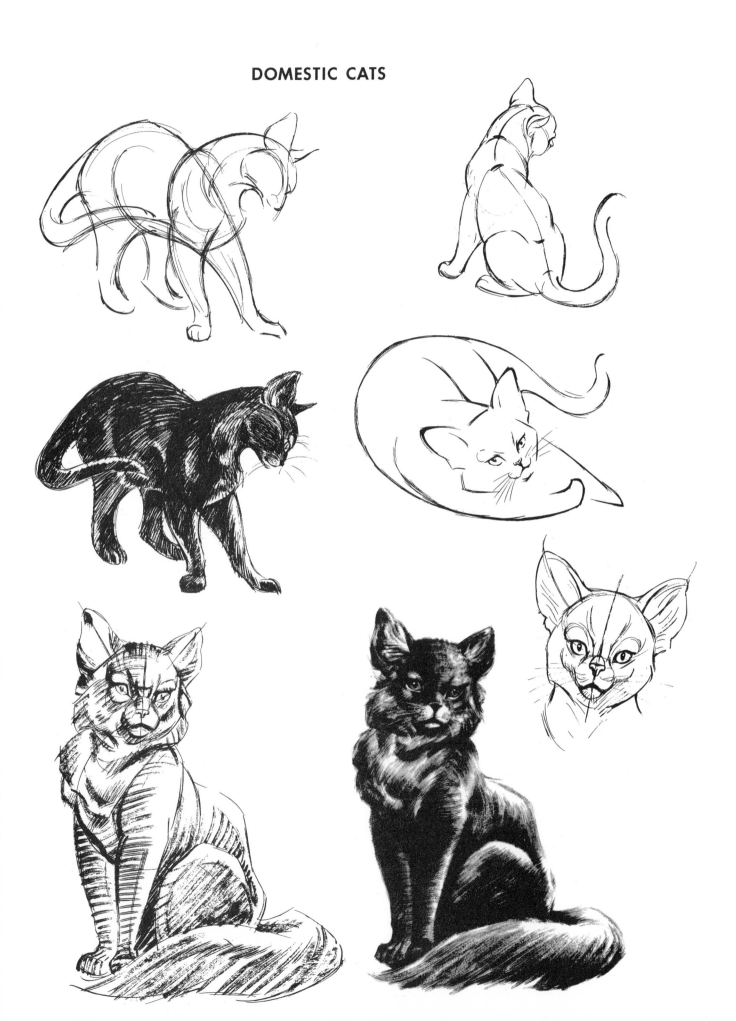

KITTENS

As in all baby animals, the body is short, the forehead large.

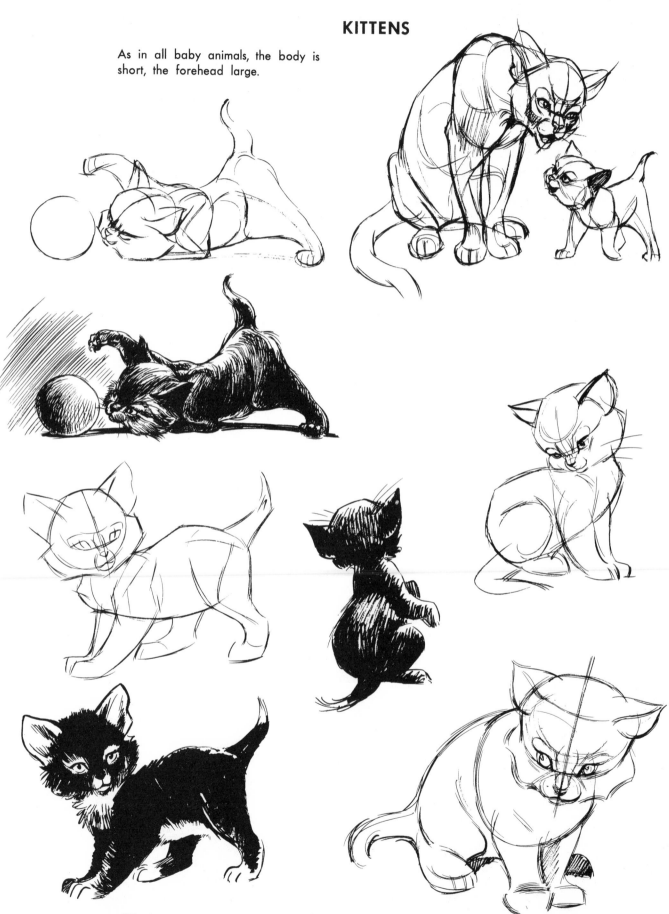

CATS—CARICATURE

I like to emphasize the sleekness and rhythm of the black panther — the long, tapering legs and long body.

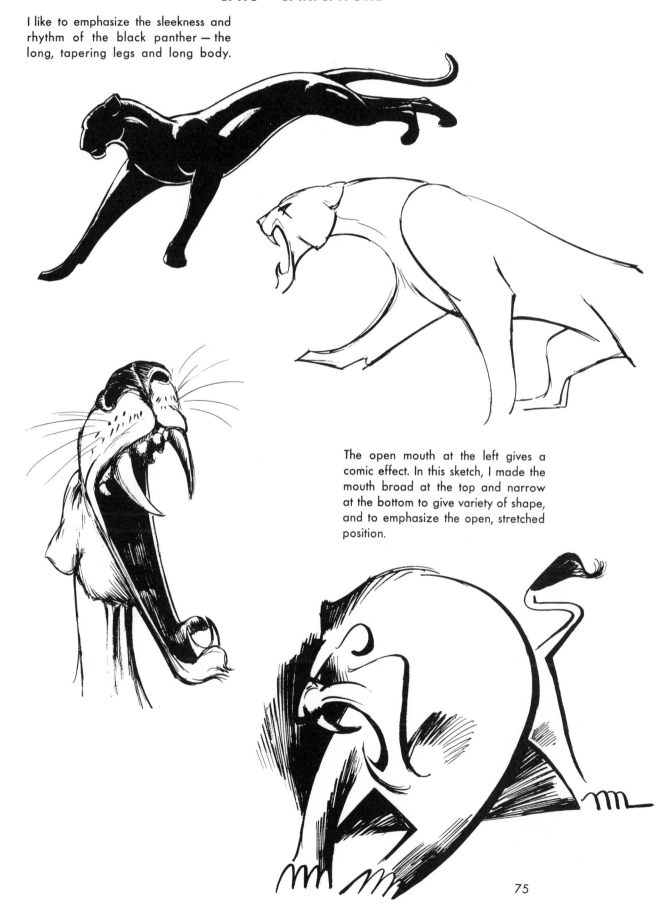

The open mouth at the left gives a comic effect. In this sketch, I made the mouth broad at the top and narrow at the bottom to give variety of shape, and to emphasize the open, stretched position.

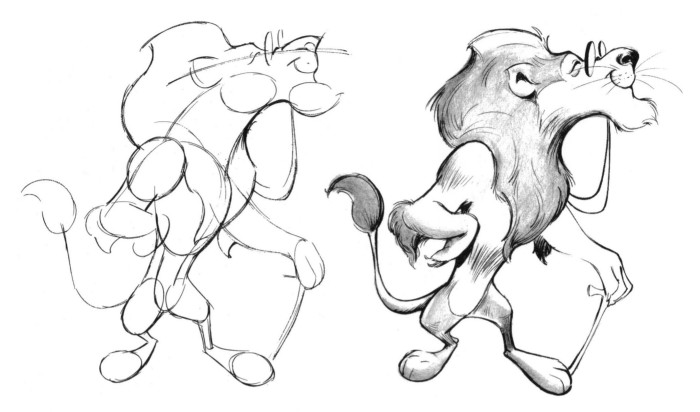

In the comic type above, I emphasized
the size of his head, mane, and chest
region. The chin whiskers are exager-
rated, and the tip of the tail is full
to obtain a flare effect.

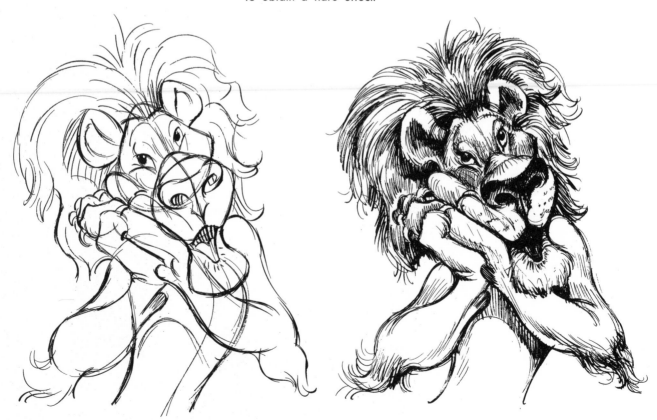

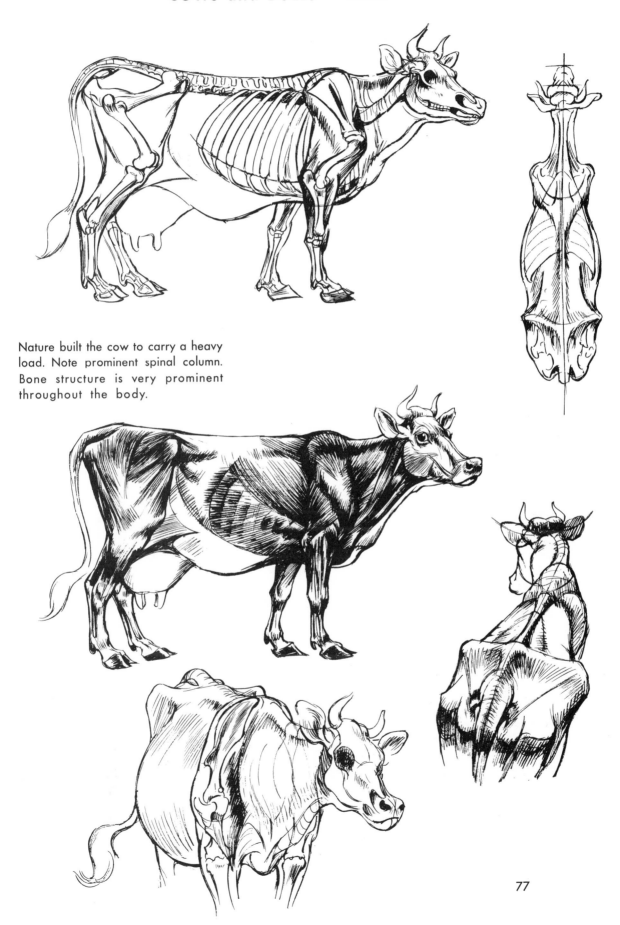

Nature built the cow to carry a heavy load. Note prominent spinal column. Bone structure is very prominent throughout the body.

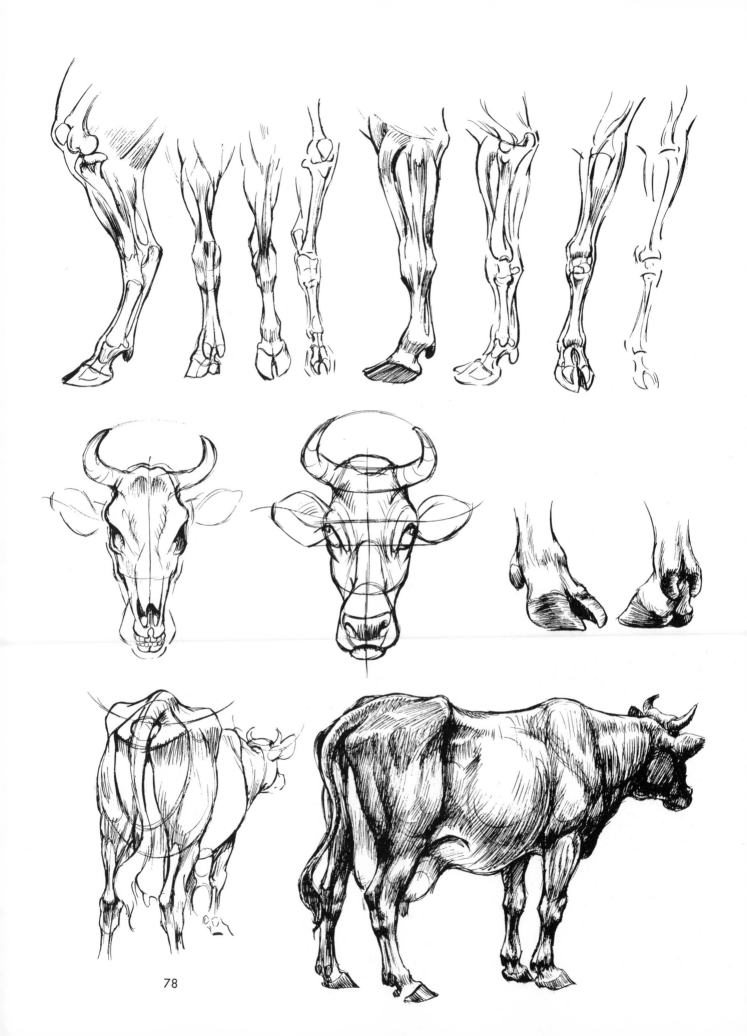

78

COWS—CARICATURE

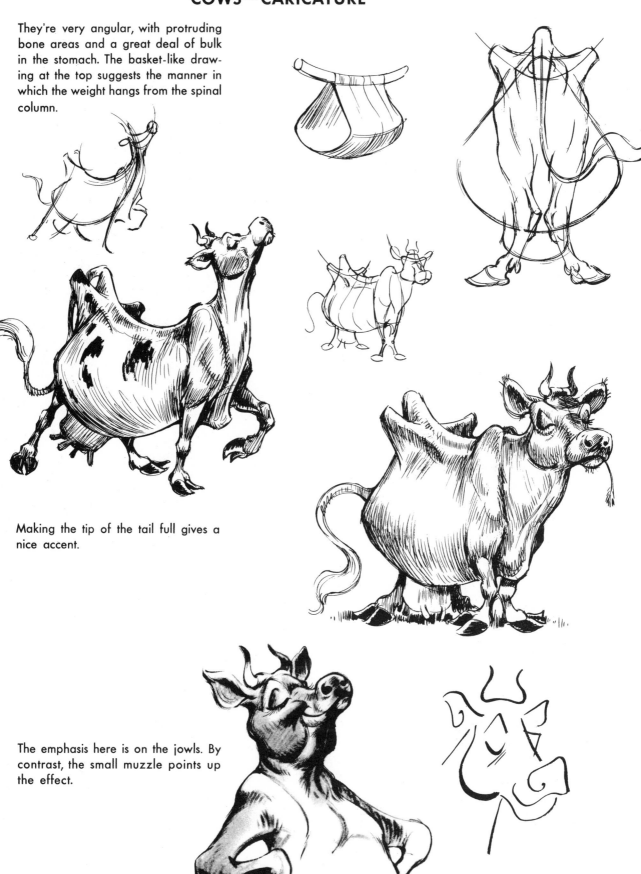

They're very angular, with protruding bone areas and a great deal of bulk in the stomach. The basket-like drawing at the top suggests the manner in which the weight hangs from the spinal column.

Making the tip of the tail full gives a nice accent.

The emphasis here is on the jowls. By contrast, the small muzzle points up the effect.

79

BULLS

The neck and shoulders are thick and solid. There is a good deal of loose skin hanging on the under part of the neck.

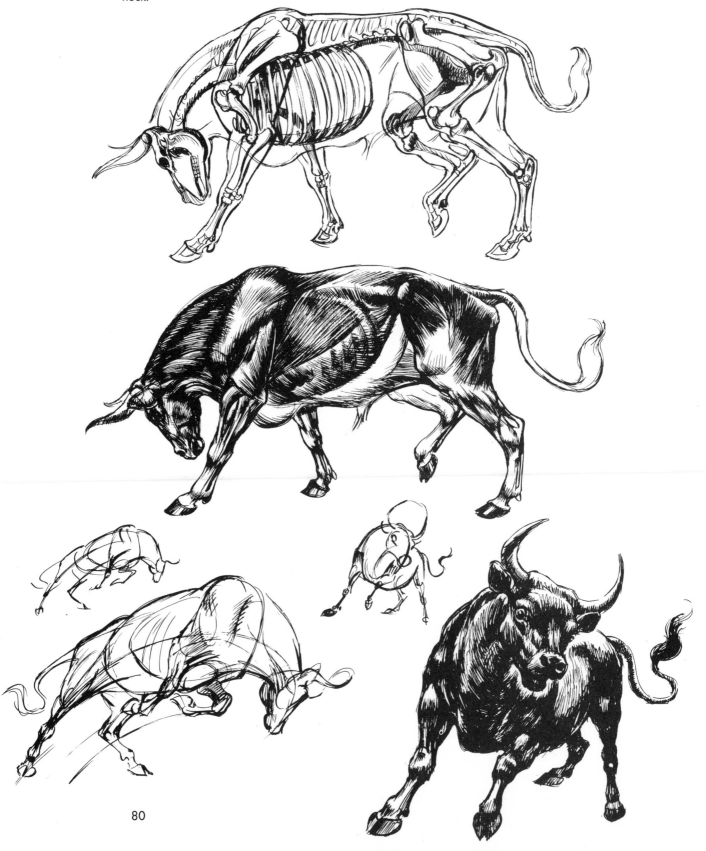

BULLS—CARICATURE

Here I have emphasized the neck and forequarter section and dwarfed the size of the legs to give more bulk to the body. The length of the horns is exaggerated, and the tip of the tail is made very full to serve as an accent.

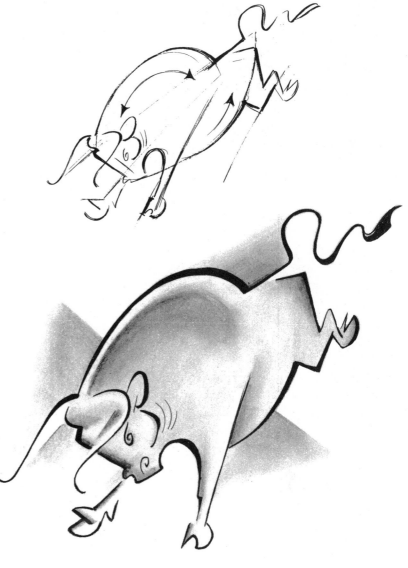

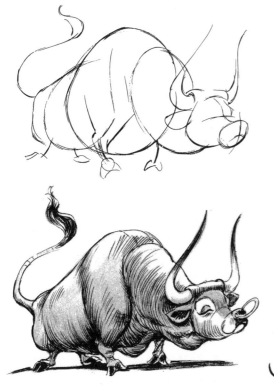

For an incongruous effect, I have used very thin legs on the characters below.

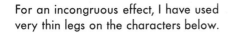

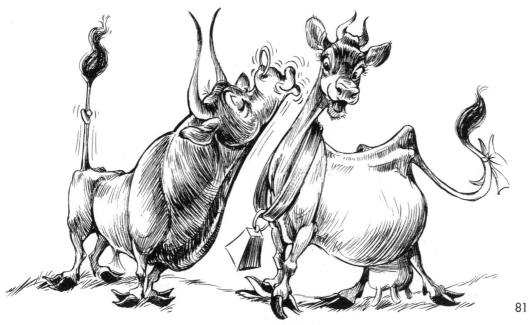

GIRAFFES

The giraffe is very angular animal, with a wide jaw and a pointed, V-shaped nose. The upper lip is split, and the eyes protrude somewhat from the side of the head. The hindquarter section is set low, in contrast to the high withers.

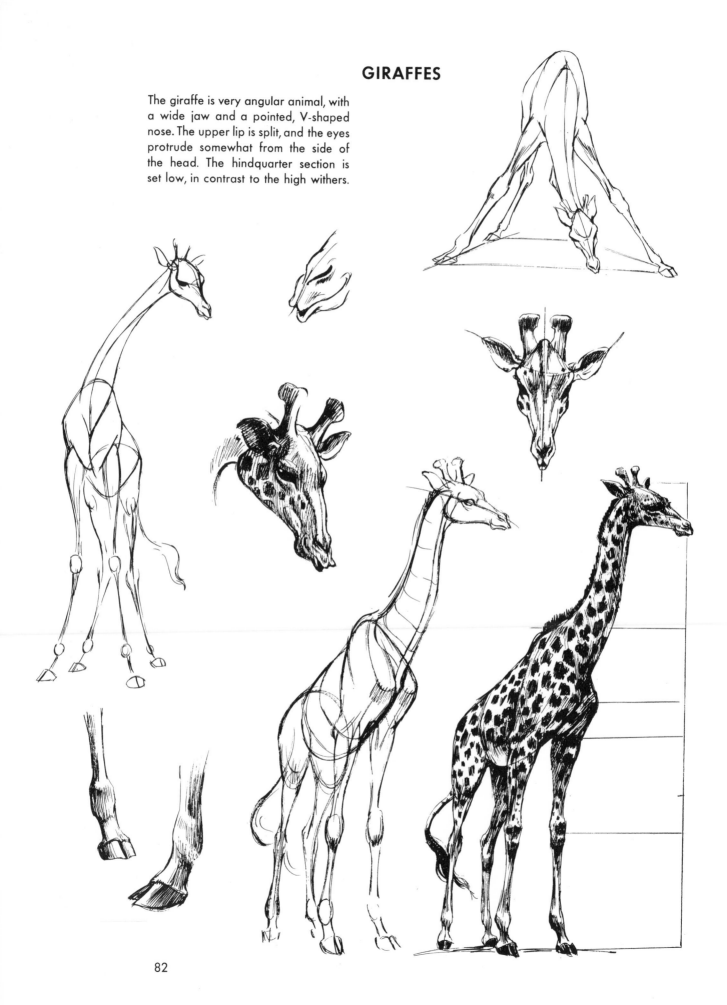

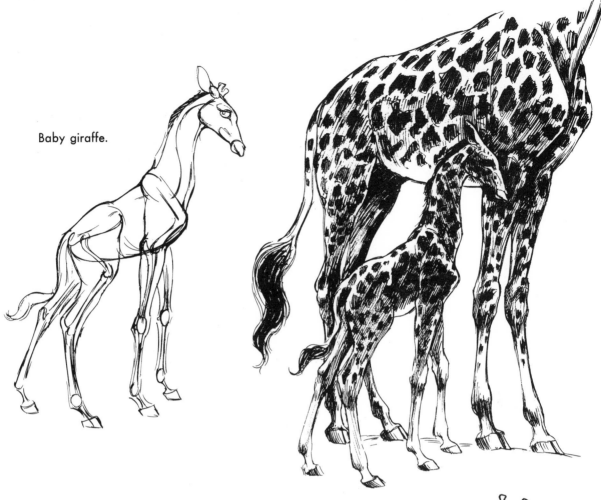

Baby giraffe.

GIRAFFE—CARICATURE

Points of exaggeration:

Spread horns
Long neck
Very angular
Knock-knees
Split lip
Very high at the shoulder
Very low in rear
Flared tail
Long split hoof

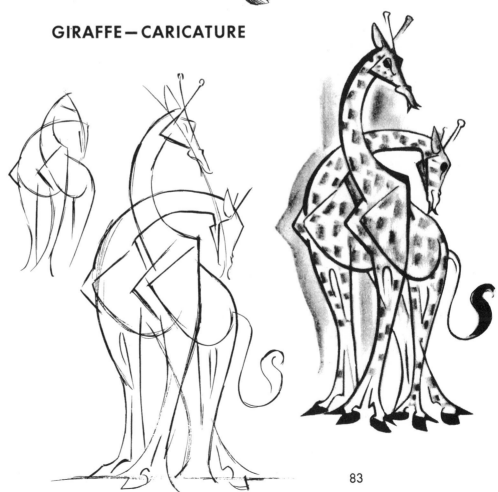

CAMELS

A camel has many dominant characteristics. He is a very leggy animal with a deep chest. To me, his most unusual feature is the very small area on which the hindquarters are set. Unlike most animals, the angle of the eye is different from that of the mouth. The eyes are wide-set, and protrude from the head, somewhat like those of the giraffe.

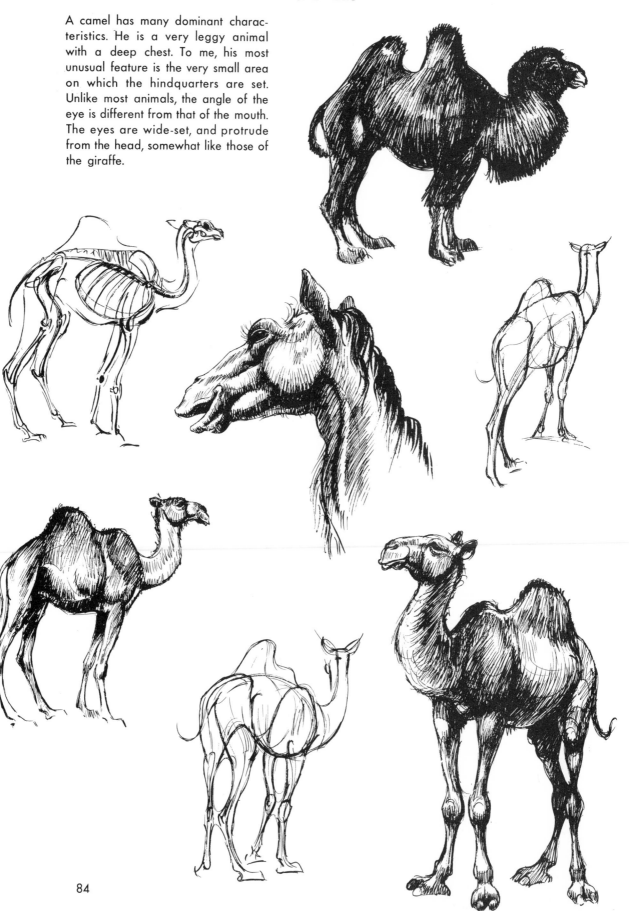

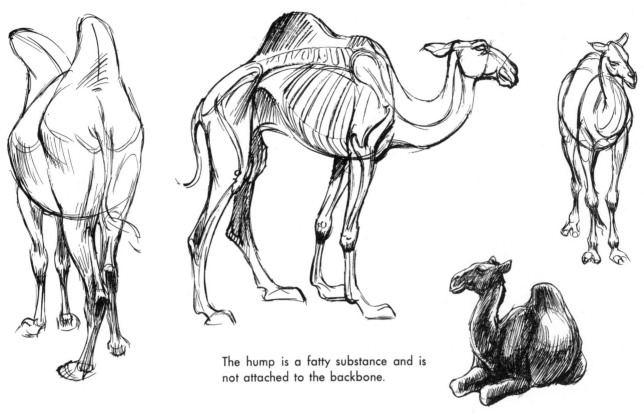

The hump is a fatty substance and is not attached to the backbone.

CAMELS — CARICATURE

Being caricatures in themselves, camels are comparatively easy. I emphasize the following points: very small pelvic region where hind legs attach to body, long lower lip, hump (accentuated by making it wider at top.)

GORILLAS

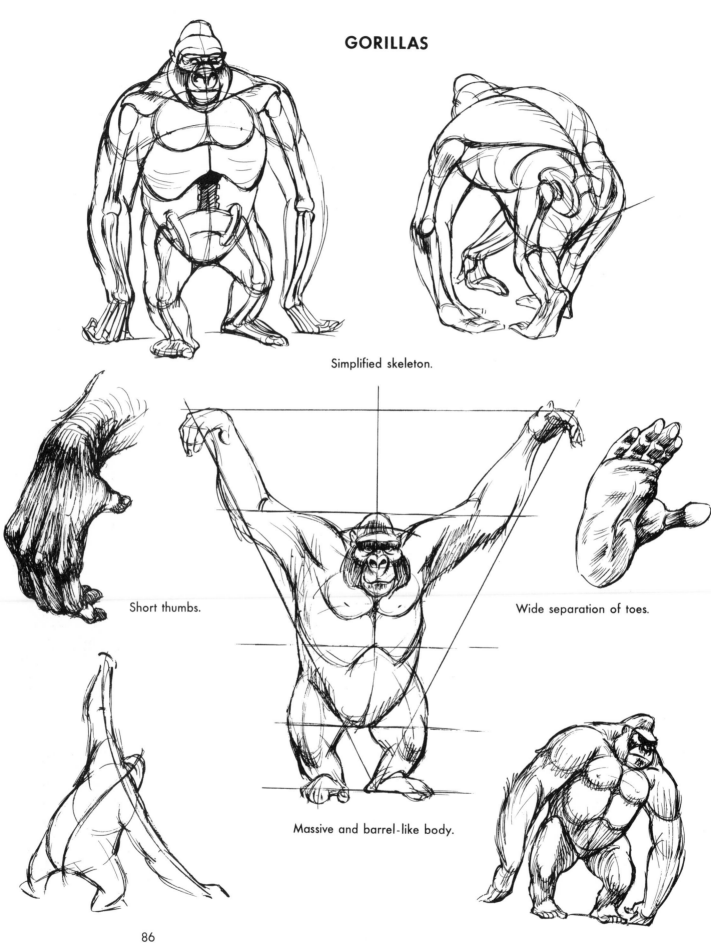

Simplified skeleton.

Short thumbs.

Wide separation of toes.

Massive and barrel-like body.

86

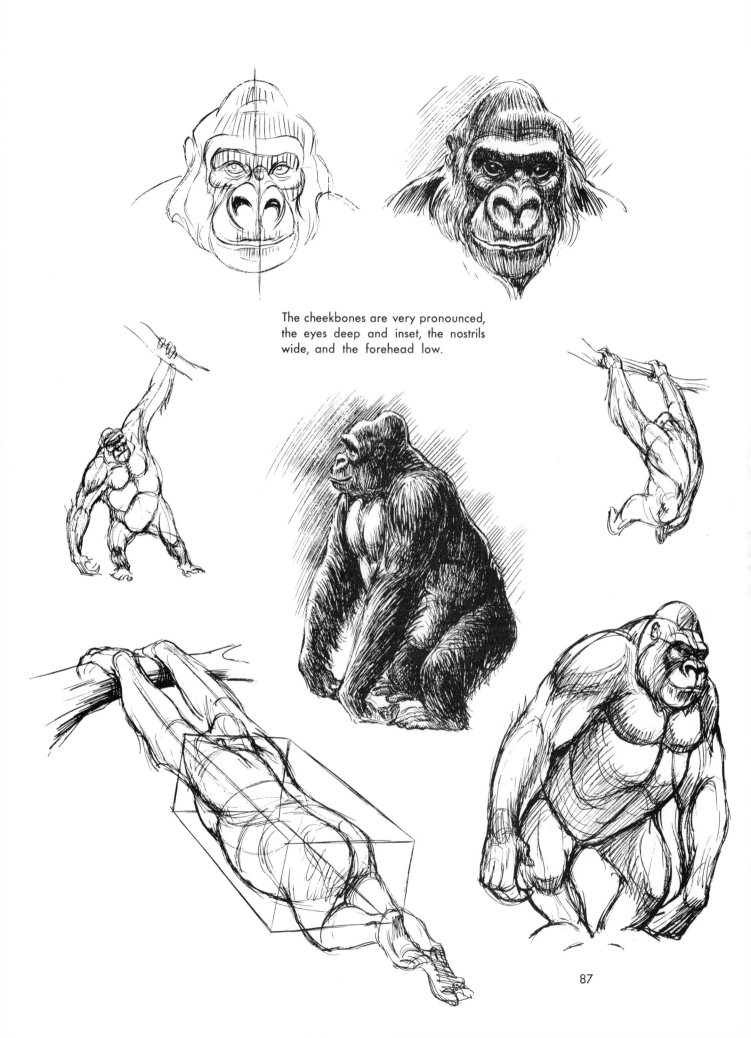

The cheekbones are very pronounced,
the eyes deep and inset, the nostrils
wide, and the forehead low.

GORILLAS — CARICATURE

For the comic type, I have exaggerated the size of the chest and arms, in relation to the small legs. The points which I believe give this drawing a silly appearance are: the long upper lip, broad mouth, small pointed crown, and long arms in contrast to short legs.

To convey the feeling of formidable power to this "menace" type, I have exaggerated his powerful shoulders and arms. The head is buried right in the body, and the size of the mouth is exaggerated. The small crown helps to accentuate, by contrast, the massiveness of the body.

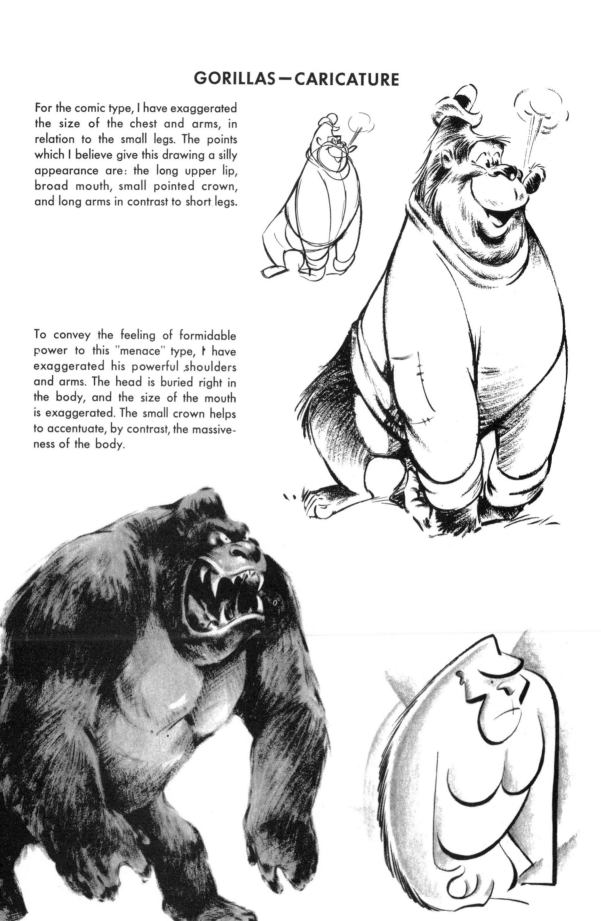

PIGS

In spite of their fullness, don't go too round on their forms. The sketch below shows how fat hangs over the body.

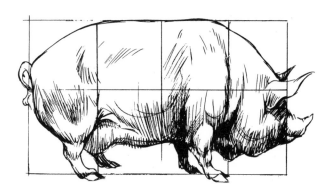

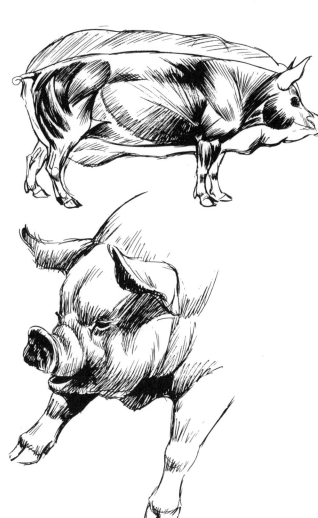

Note the breaks on the back. I use this division for all animals.

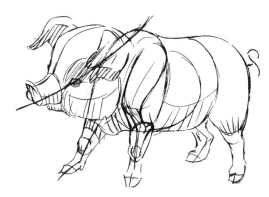

The piglet's high forehead gives him cuteness. Keep the body relatively short.

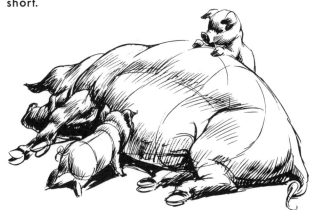

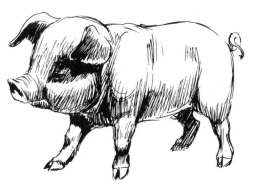

WART HOGS

The bone structure is very similar to that of its domestic cousin. The nose is longer; the ears are more erect, and do not hang like the domestic pig's.

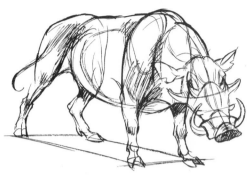

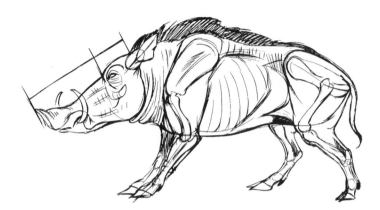

There is hair running from the fore-head almost to the middle of the back.

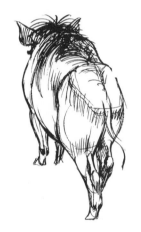

From the back the wart hog closely resembles the common pig.

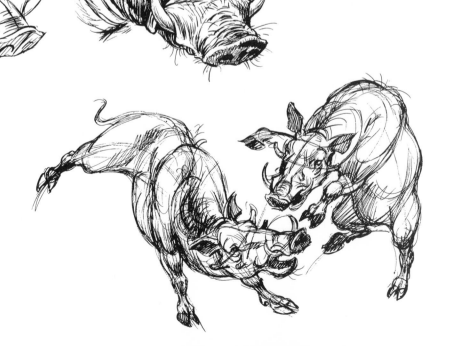

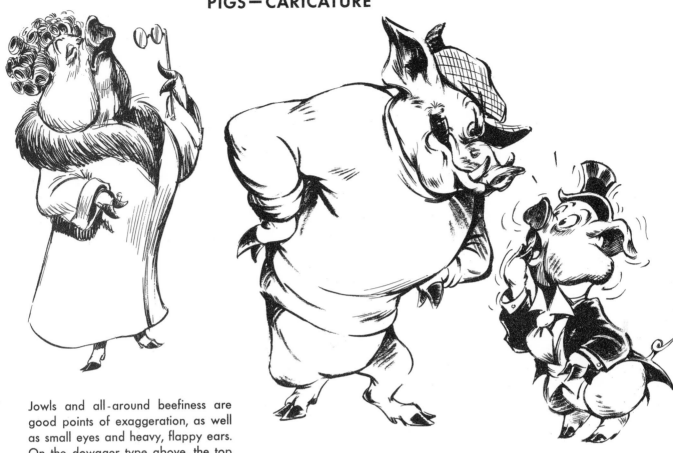

Jowls and all-around beefiness are good points of exaggeration, as well as small eyes and heavy, flappy ears. On the dowager type above, the top of the head is small so that the curls will have more flare. On the pig below the narrow shoulders emphasize, by contrast, the size of the stomach.

In "menace" wart hog type, note volume of chest and how head is buried right in the chest.

In caricature, make use of contrasting types as much as possible. Contrast establishes types more definitely.

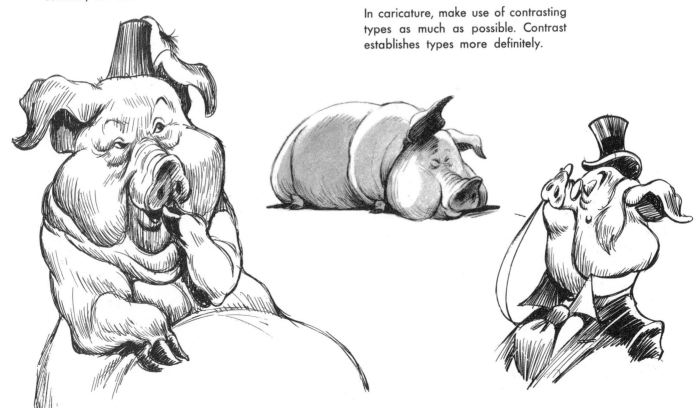

DOGS

Dogs vary in conformation and size, but are closely alike in many respects. Below are two simplified skeletons for two different types. They are kept the same except for relative size of parts of the skeletons. Keep in mind the character of the dog — for example, the long back and short legs of a dachshund contrasted with the relative short squareness of an English bull.

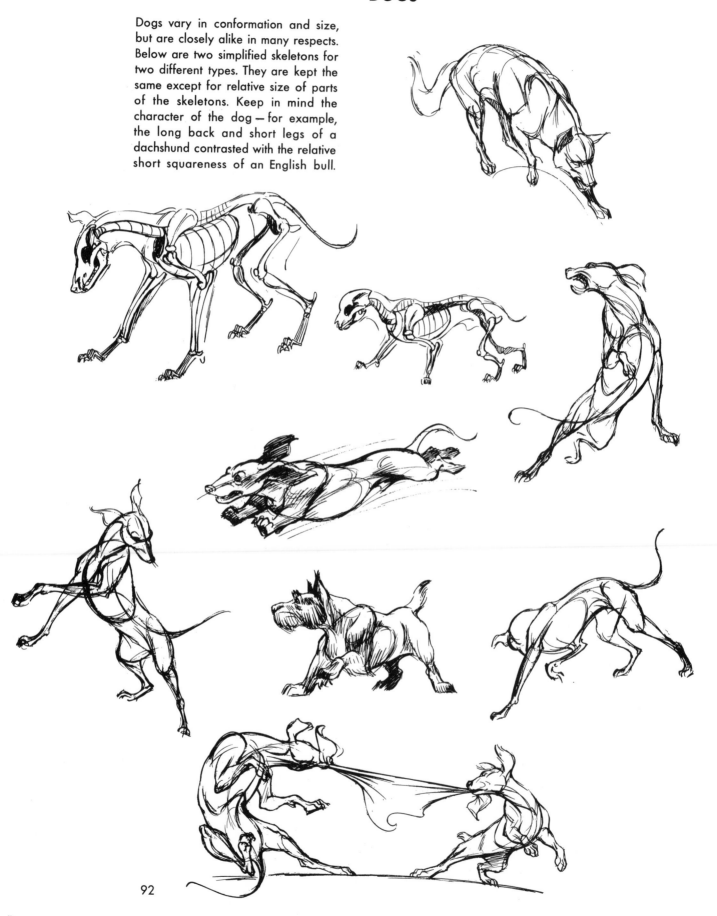

DACHSHUND

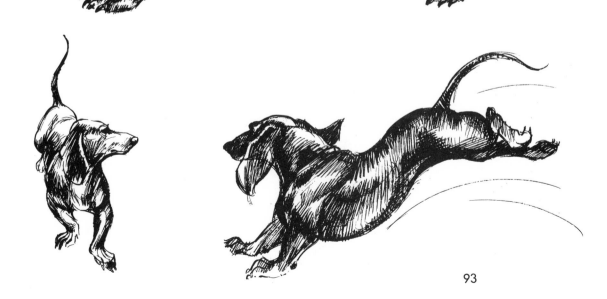

ENGLISH BULL

The English bulldog is broad of chest, with a flat nose and over-all blunt features.

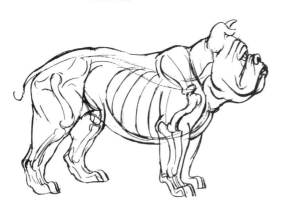

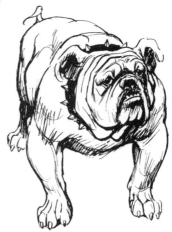

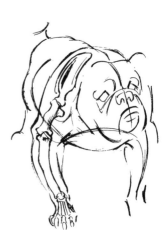

Note the bowlegs.

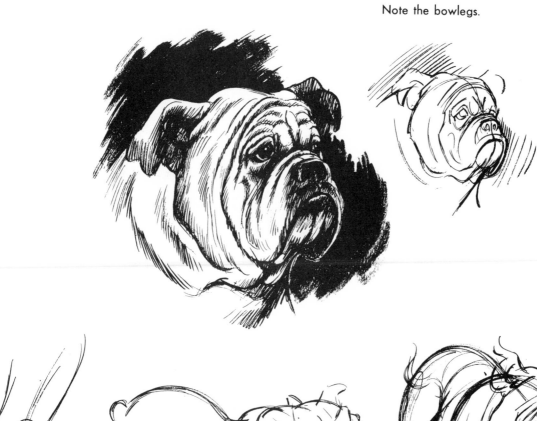

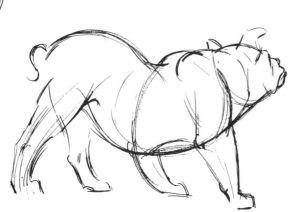

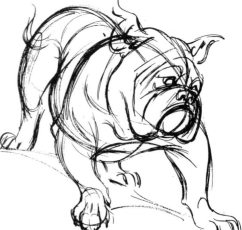

GREYHOUND

In the greyhound and whippet breeds,
the bone structure is very pronounced.
They are extremely flexible in body.

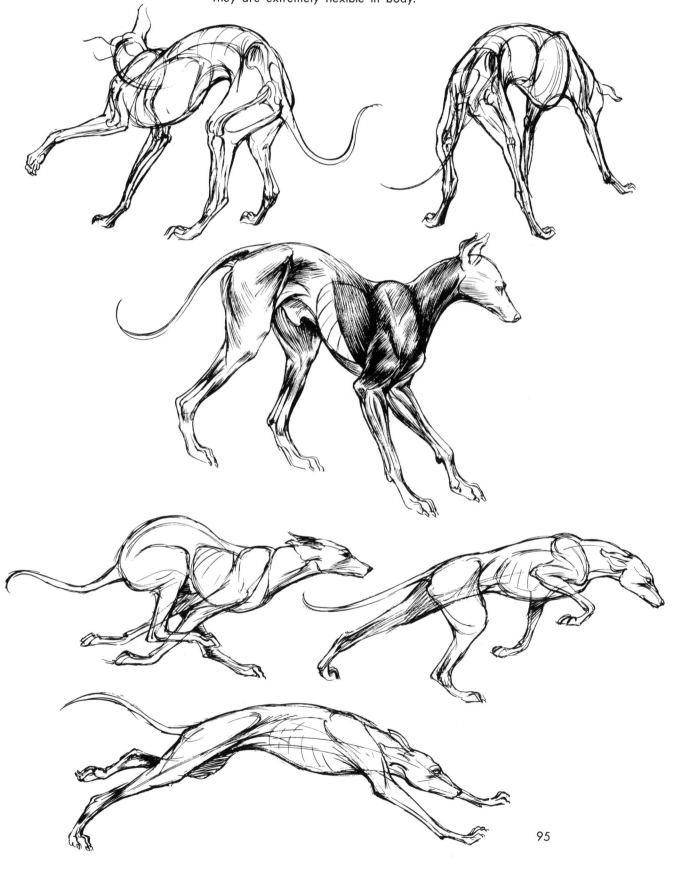

COCKER

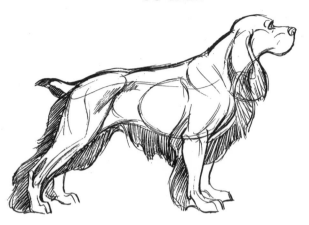

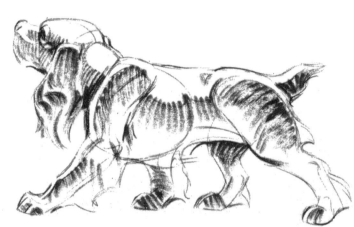

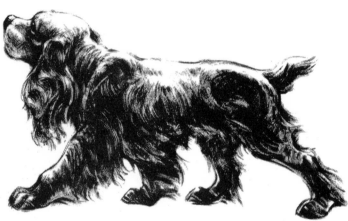

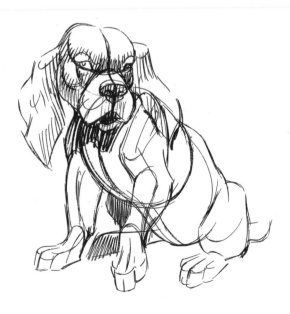

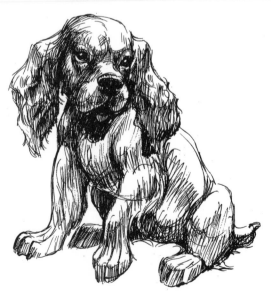

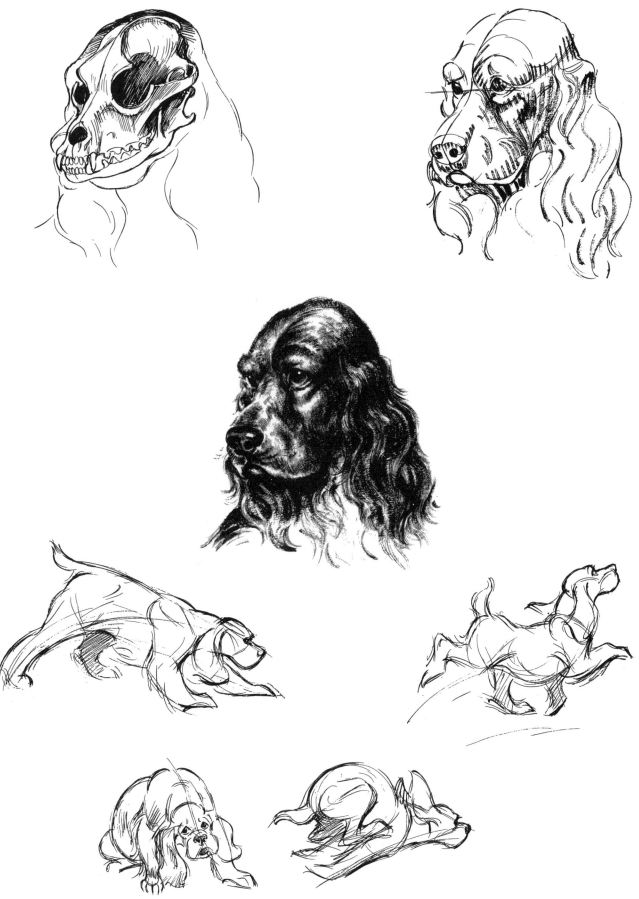

GREAT DANE

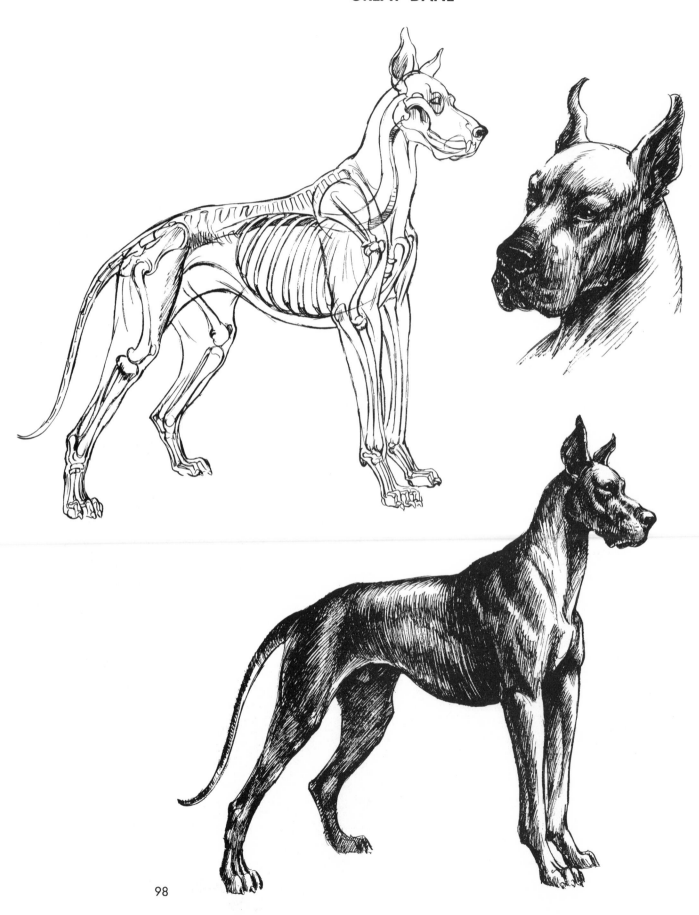

COLLIE

Stripped of his long hair, a collie is
lean. Work for long sweeping lines
when sketching in.

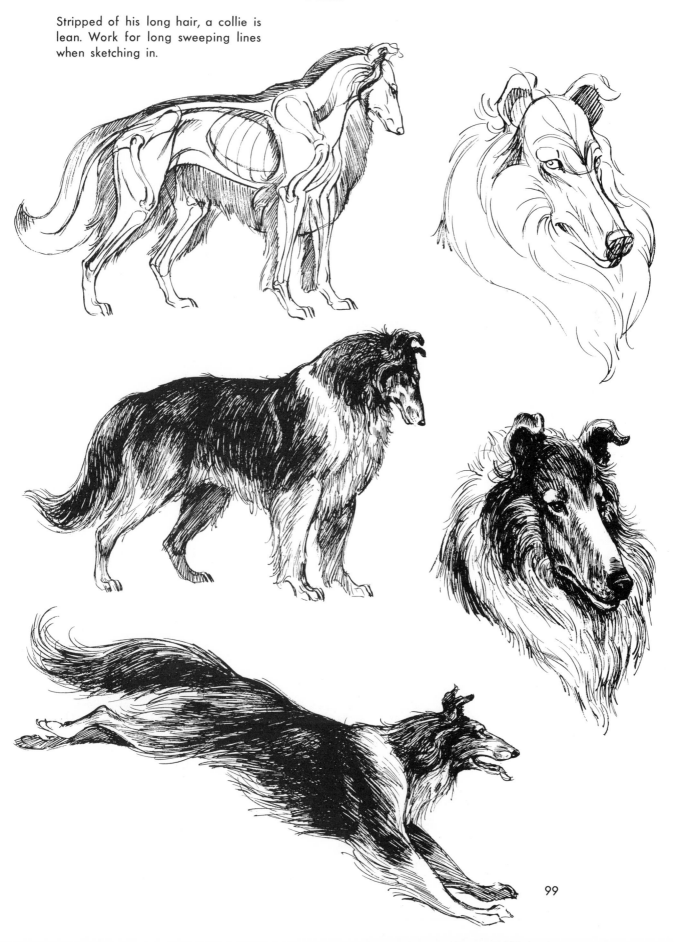

DOGS — CARICATURE

Dogs are marvelous for caricature because of the many contrasting types. When you have several together, work for opposite types. This will make each one stand out more definitely.

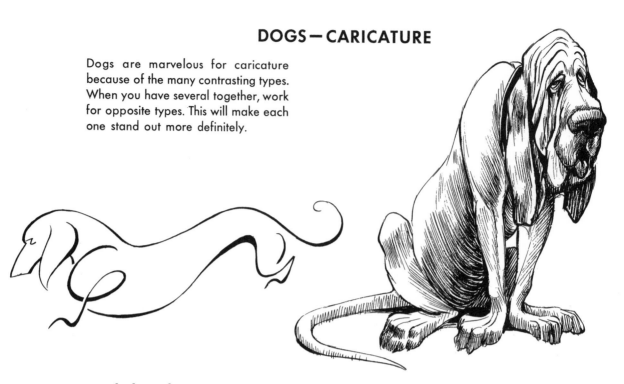

Dachshund

Exaggerated length of body, long pointed head, and length of ears.

Bulldog

Exaggerated heaviness of chest, short, stocky bowlegs, and massive jaw. The spiked collar helps in this case to establish the character of the dog.

Bloodhound

Exaggerated angular body, size of nose, and loose skin on the head. The ears are low to give a heavy effect.

Sheep Dog

Exaggerated woolliness. The tail was flared for accent.

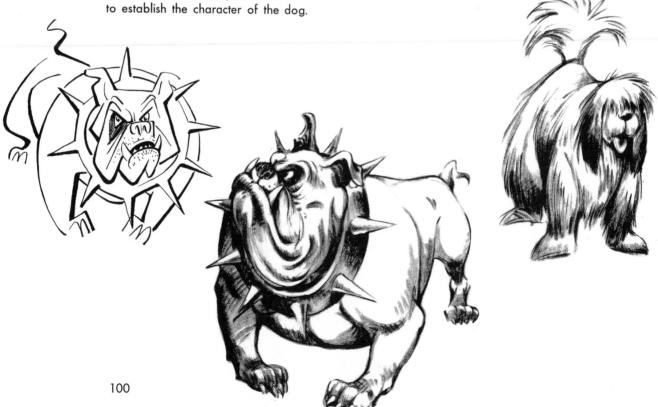

FOXES

Some of the salient characteristics are: a small, pointed muzzle and nose, slanted eyes, large pointed ears, and small feet.

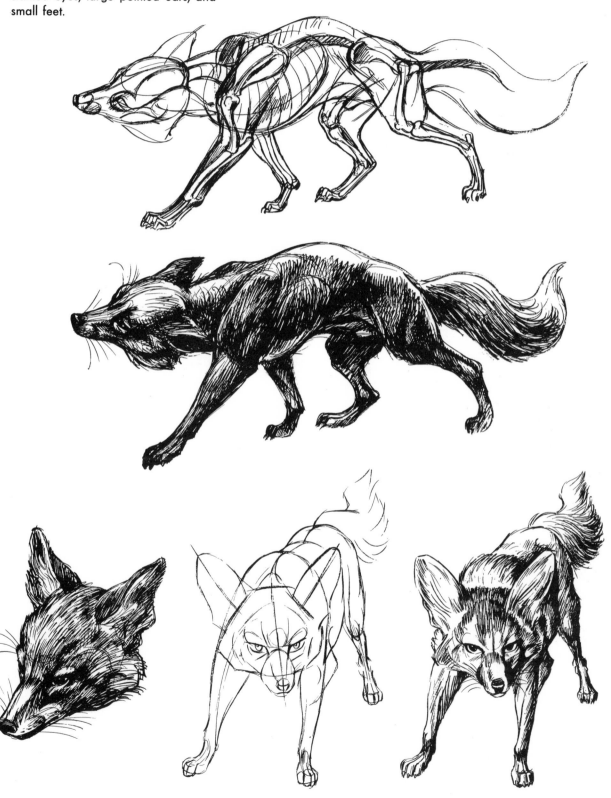

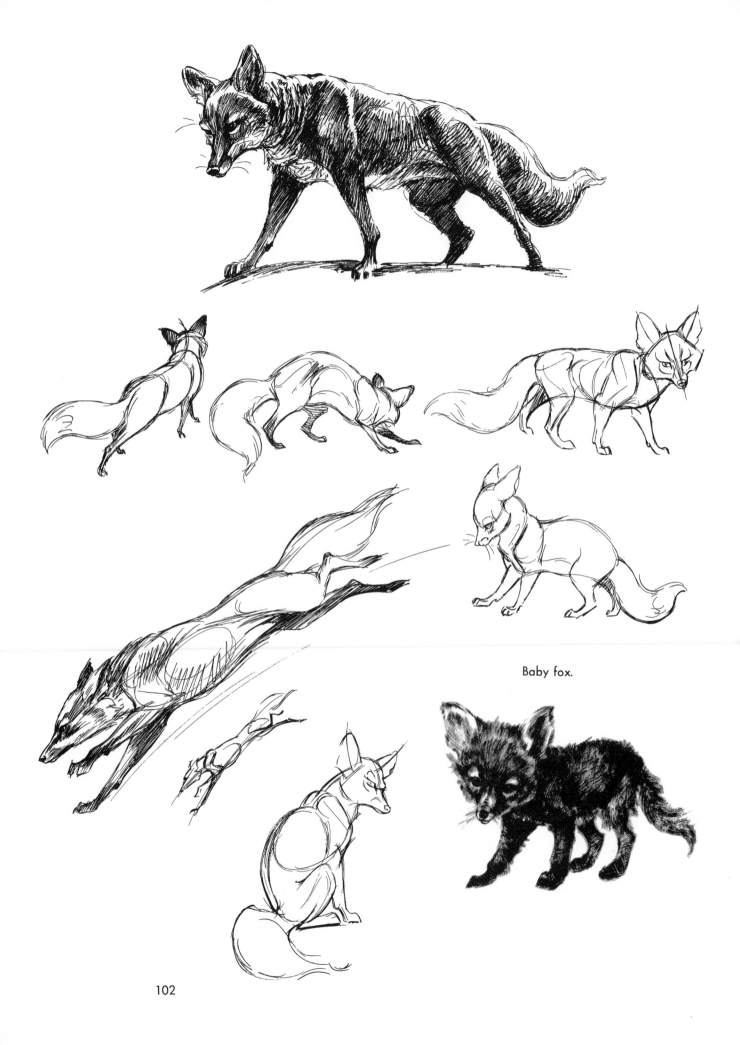

Baby fox.

FOX—CARICATURE

The fox is very flexible to handle. Here I have illustrated both the more conventional and the humanized types.

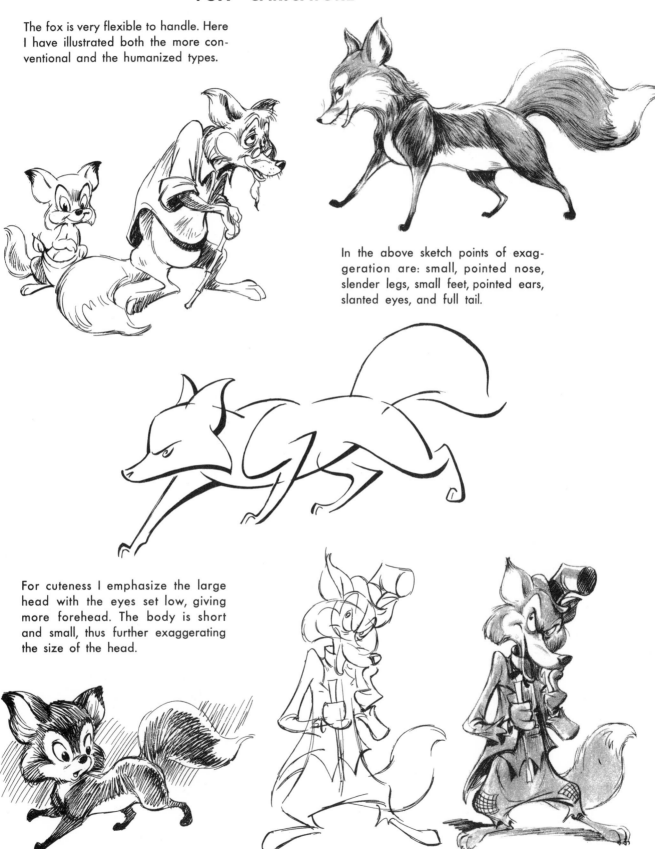

In the above sketch points of exaggeration are: small, pointed nose, slender legs, small feet, pointed ears, slanted eyes, and full tail.

For cuteness I emphasize the large head with the eyes set low, giving more forehead. The body is short and small, thus further exaggerating the size of the head.

KANGAROOS

The rib cage is small, and the forelegs hang, rodent-like. Head and ears are similar to those of the deer. The tail is long and pointed and quite full at the base where it is attached to the body. The tail is very important to kangaroos, since they use it as a rudder and to help support their weight. Because of its prominence, it will give you a strong line of action, and add sweep to your drawing.

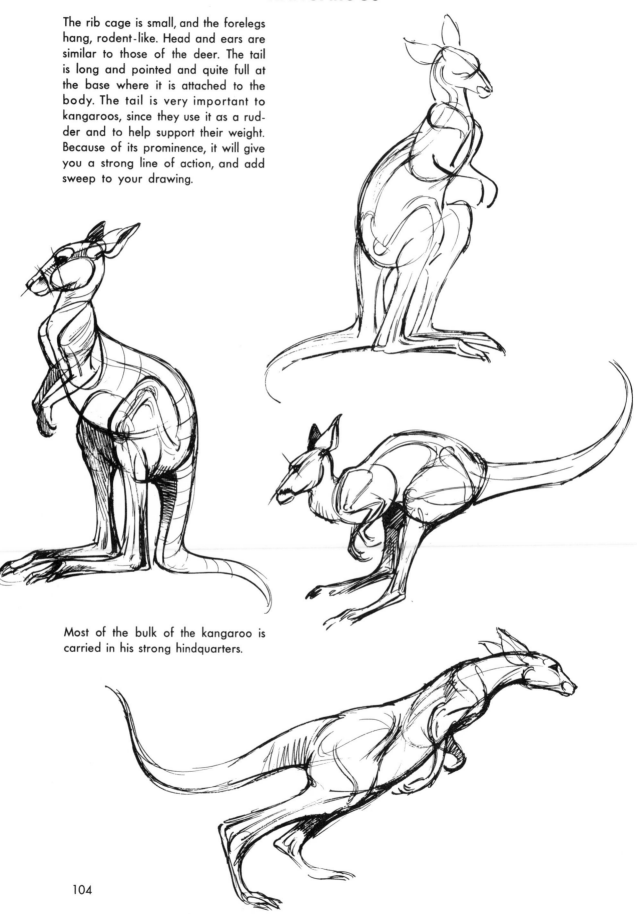

Most of the bulk of the kangaroo is carried in his strong hindquarters.

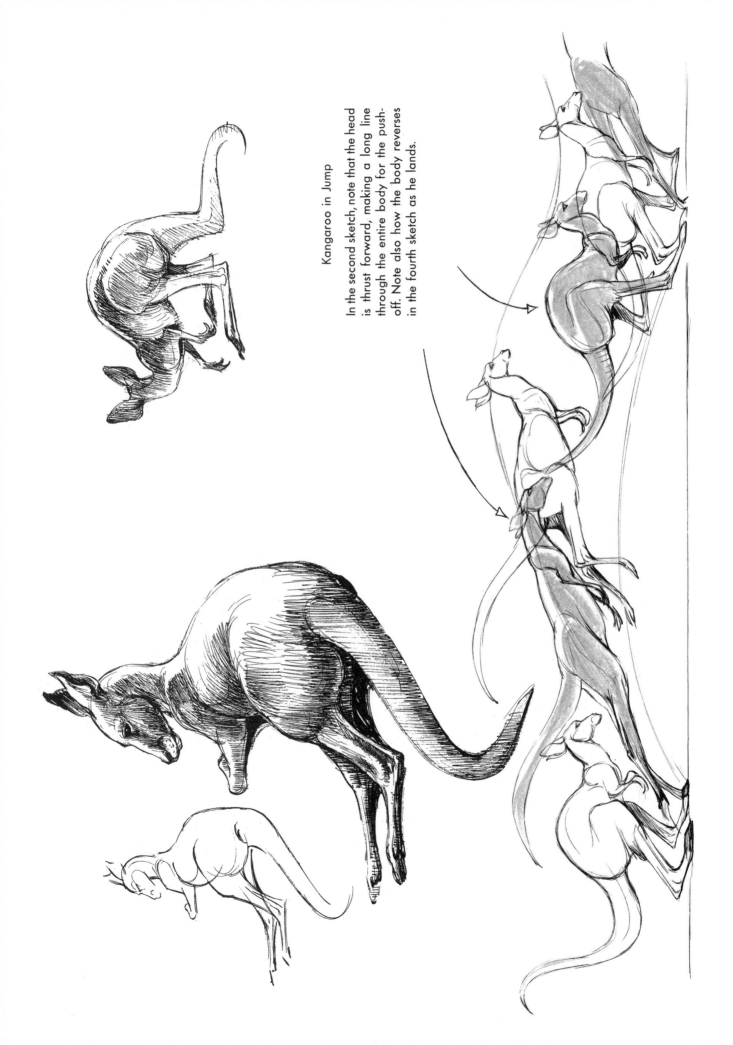

Kangaroo in Jump

In the second sketch, note that the head is thrust forward, making a long line through the entire body for the push-off. Note also how the body reverses in the fourth sketch as he lands.

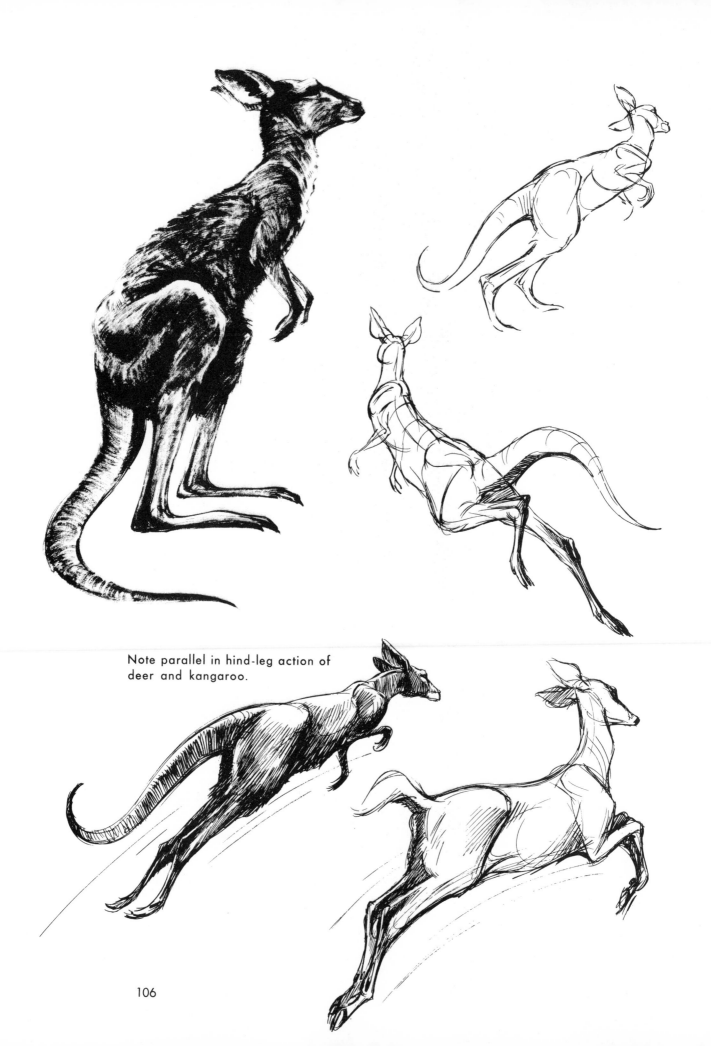

Note parallel in hind-leg action of
deer and kangaroo.

106

KANGAROOS—CARICATURE

Points of exaggeration: square nose, large full ears, thin neck. (Use this for contrast with the very large hind-quarters.)

Make markings dark on all ends: end of tail, paws, feet, and tips of ears.

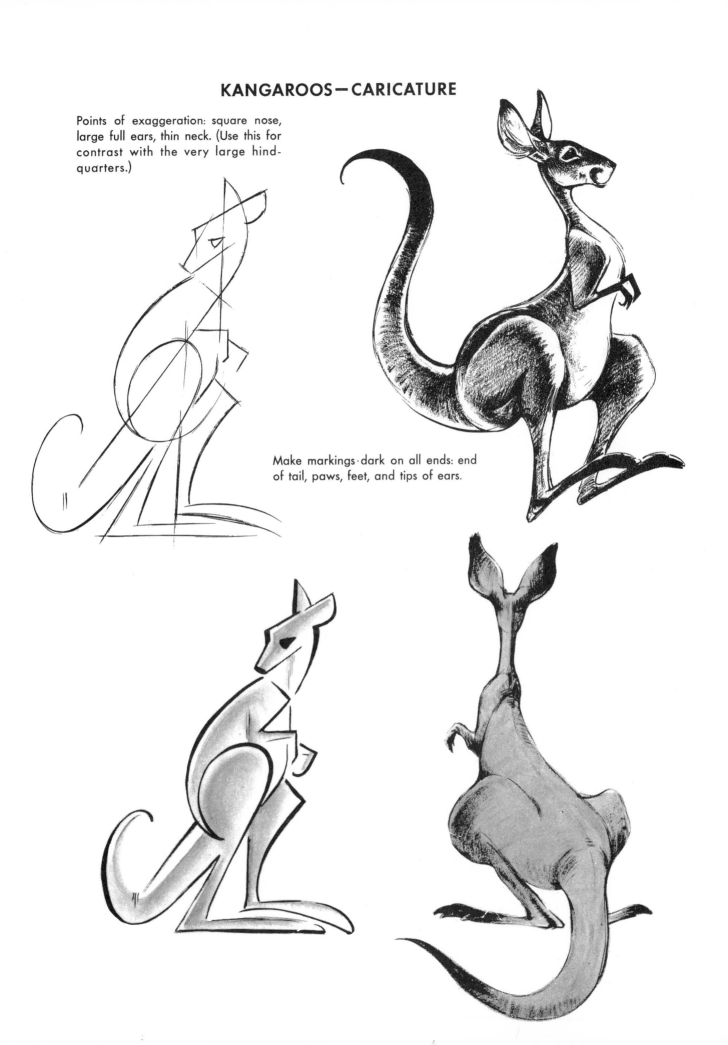

RABBITS

Their bodies are very elastic, and they double their length in stretched-out positions.

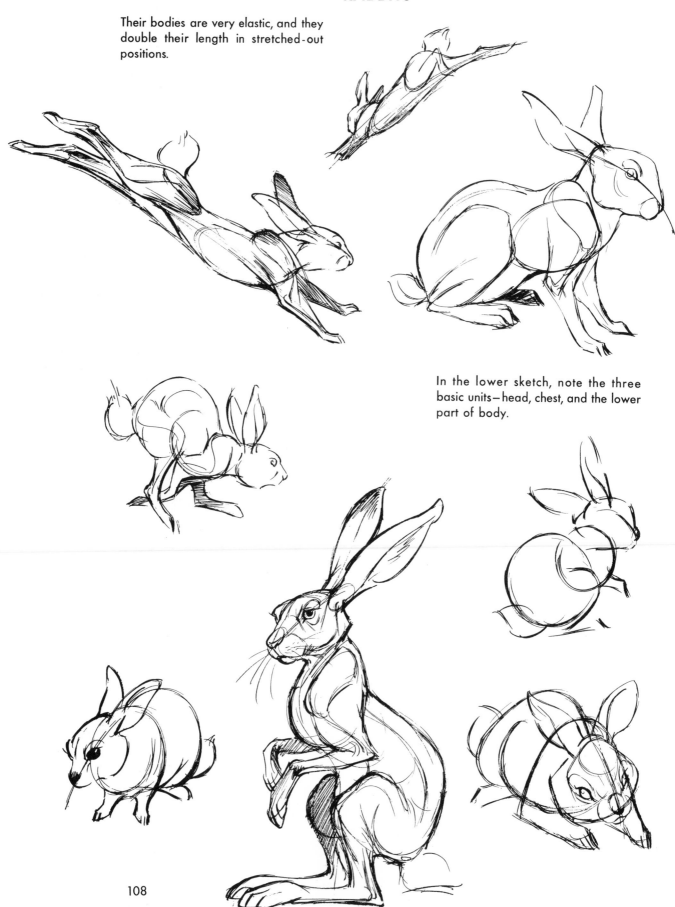

In the lower sketch, note the three basic units—head, chest, and the lower part of body.

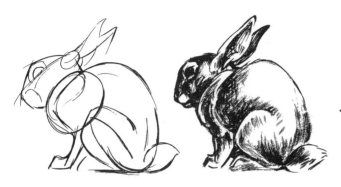

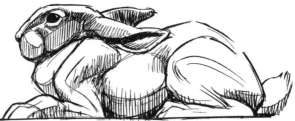

In sitting positions, you'll notice generally that there's a bunching up of forms. But studying motion-picture frames reveals that they are capable of really spreading out.

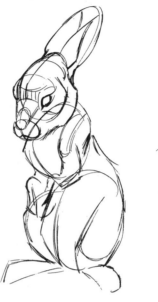

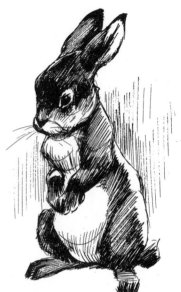

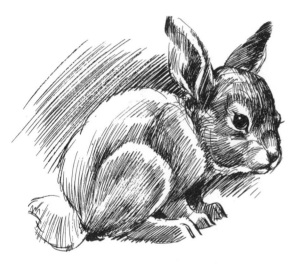

When spotting your darks, play your lights against the darks.

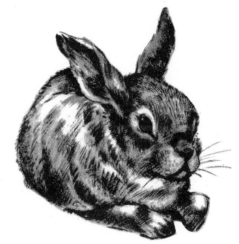

Bunnies are always fun to draw. It is well to use a dry brush for softness.

Jump

Note the bunching up and elongating of the rabbit on the take-off.

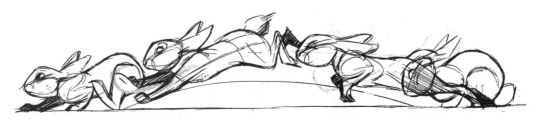

RABBITS — CARICATURE

Rabbits are excellent for humanized types, their heads and bodies are so flexible for expression. It is especially interesting to work with their jowls and muzzles. The buckteeth add to the comic effect, and their ears can be used in various ways for expression. Hang the ears for sadness; stretch them back in a surprise take, etc.

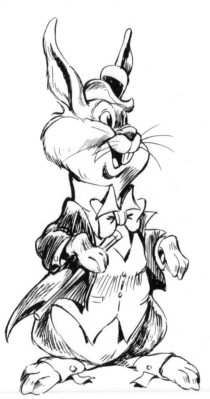

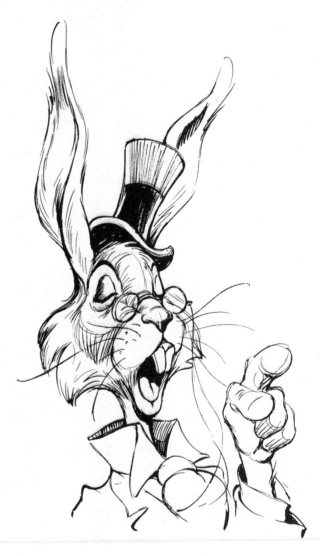

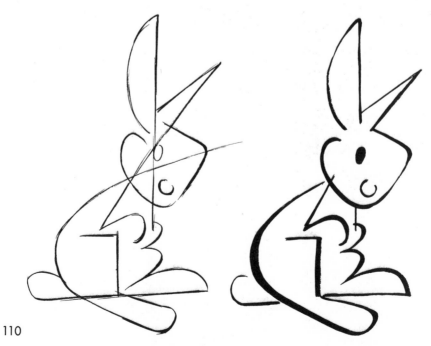

110

SQUIRRELS

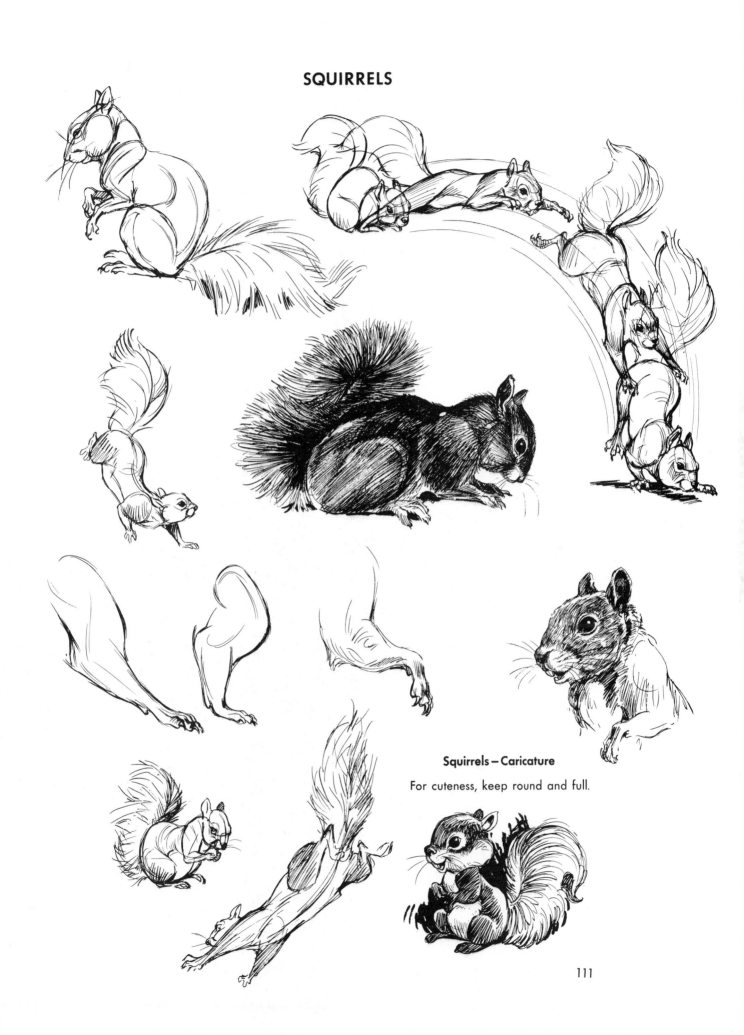

Squirrels — Caricature

For cuteness, keep round and full.

ELEPHANTS

Work for big, sweeping forms. The
elephant is a very angular animal in
spite of its tremendous bulk. There is
a very prominent vertebral column
on the back.

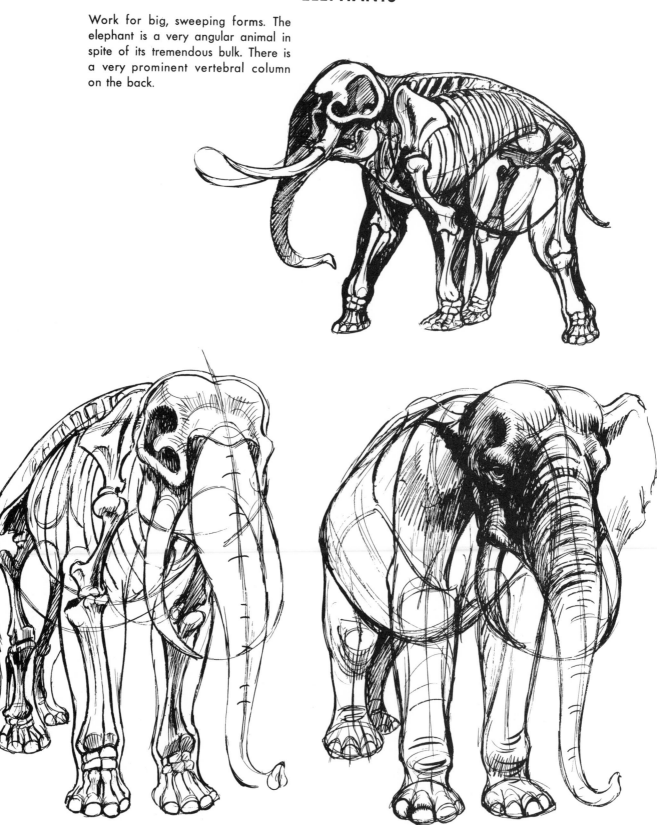

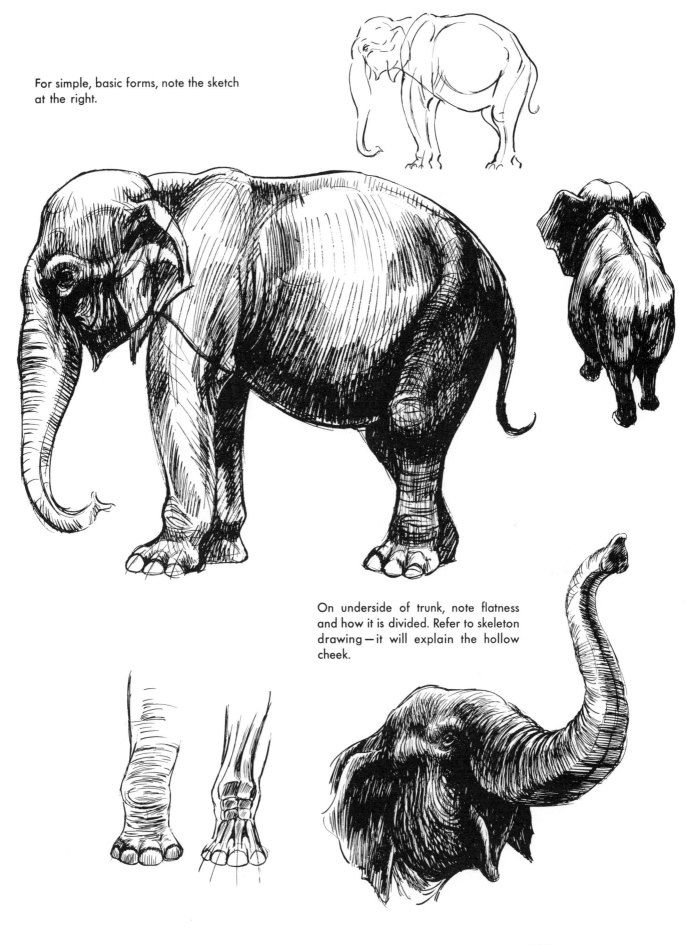

For simple, basic forms, note the sketch at the right.

On underside of trunk, note flatness and how it is divided. Refer to skeleton drawing—it will explain the hollow cheek.

113

The approach: the main forms are
rounded in.

The lesser forms are added.

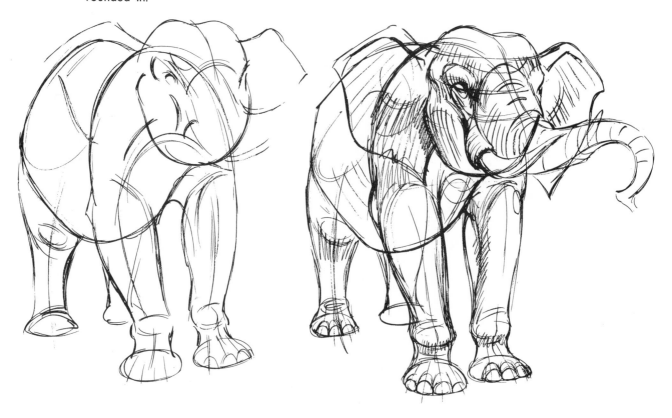

Finish off.

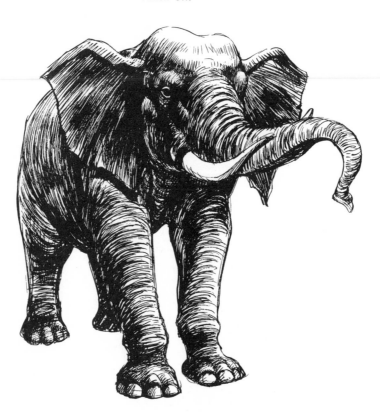

Just because elephants are big and bulky, don't be afraid to move them around. On action drawings below, note how the hind legs and trunk are used for the line of action.

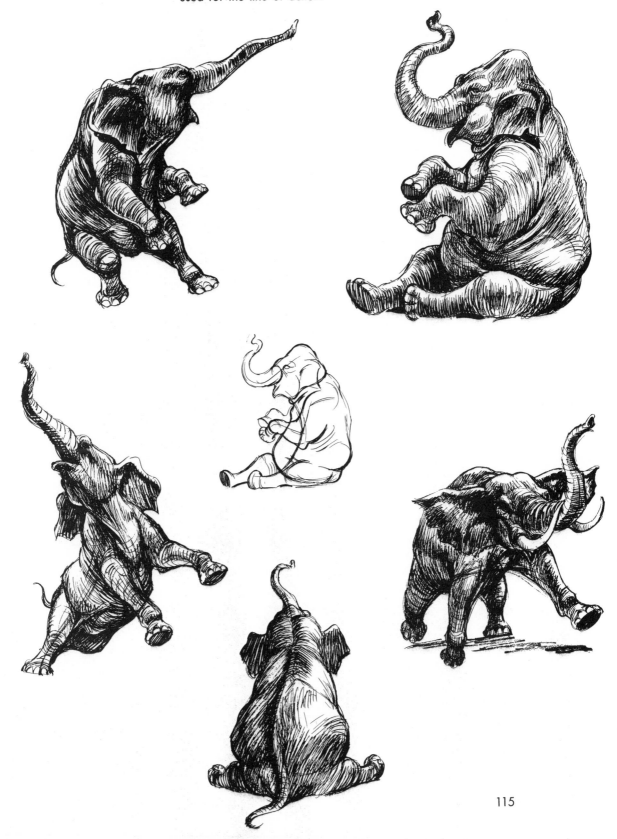

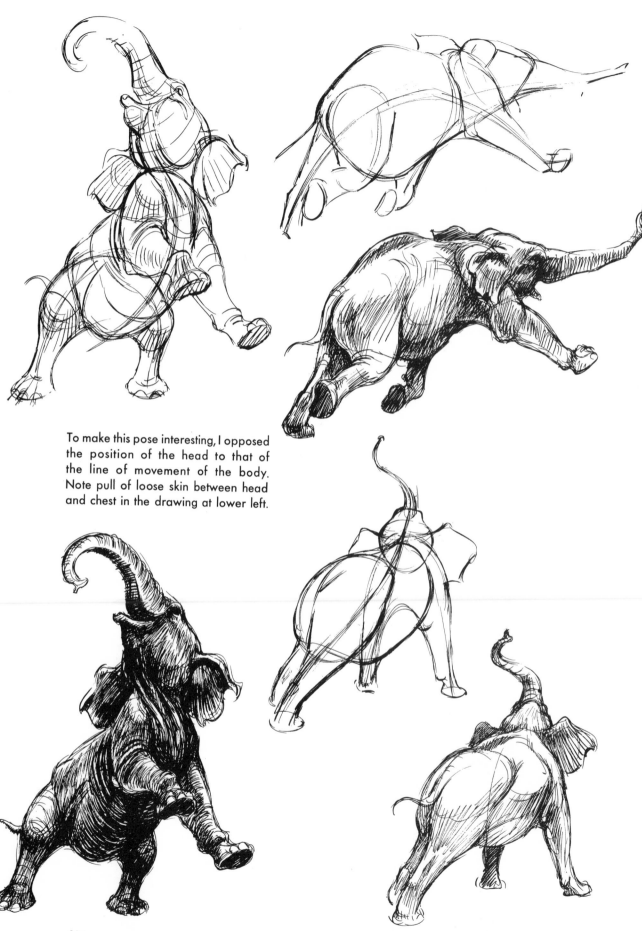

To make this pose interesting, I opposed the position of the head to that of the line of movement of the body. Note pull of loose skin between head and chest in the drawing at lower left.

116

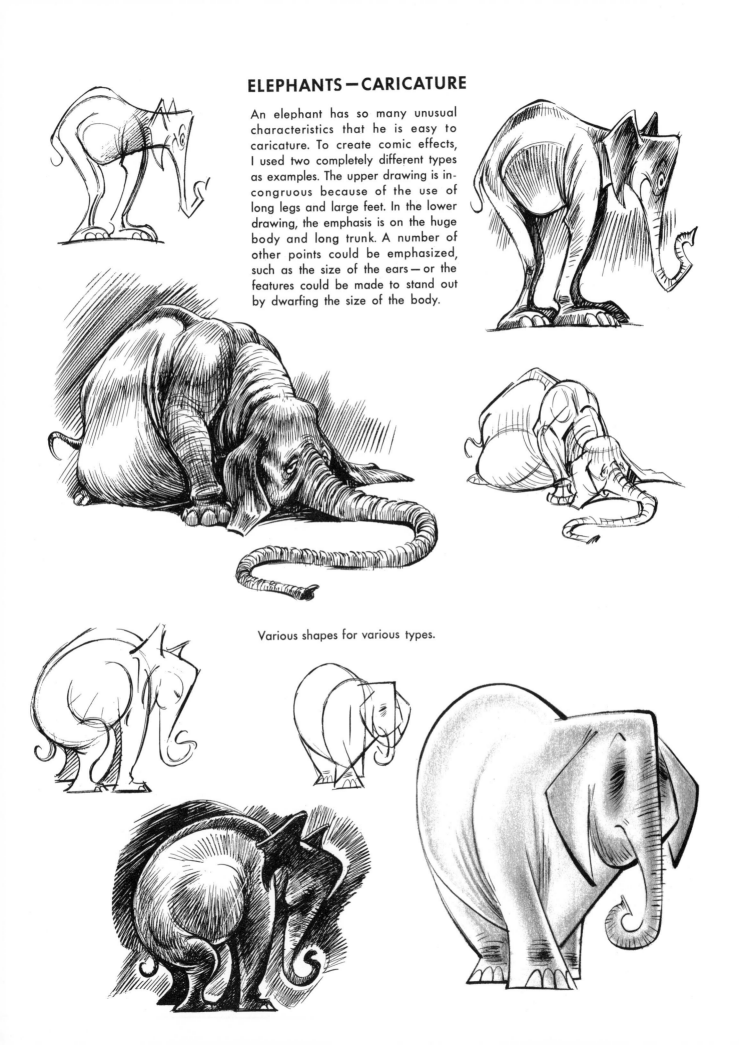

ELEPHANTS—CARICATURE

An elephant has so many unusual characteristics that he is easy to caricature. To create comic effects, I used two completely different types as examples. The upper drawing is incongruous because of the use of long legs and large feet. In the lower drawing, the emphasis is on the huge body and long trunk. A number of other points could be emphasized, such as the size of the ears — or the features could be made to stand out by dwarfing the size of the body.

Various shapes for various types.

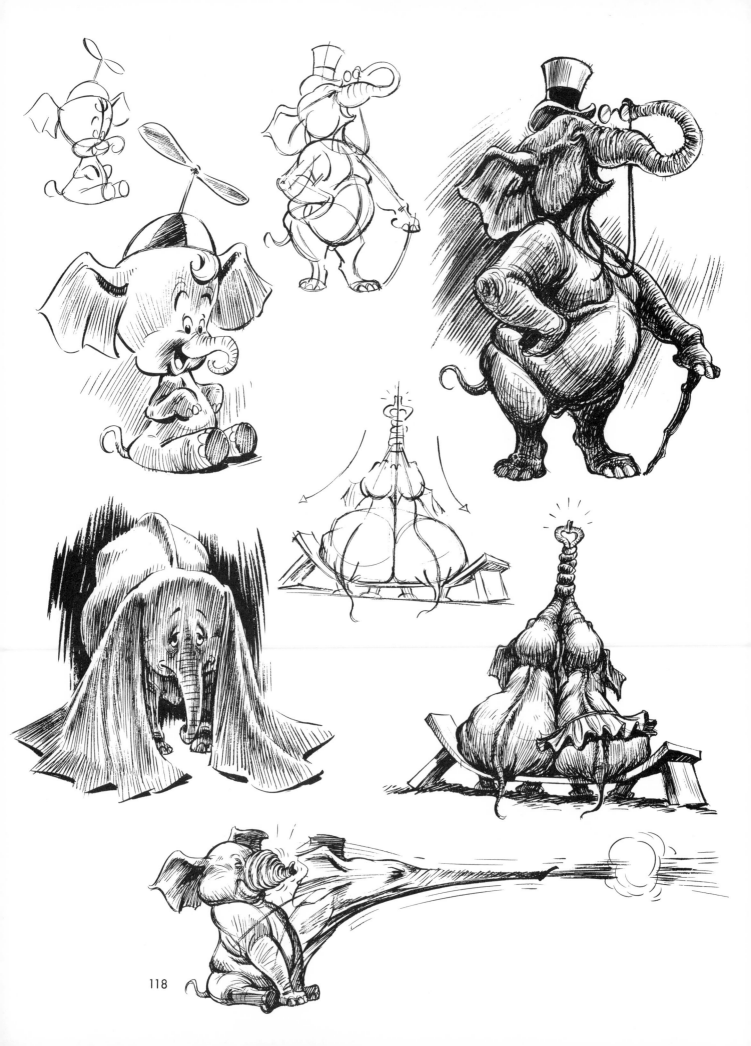

118

THE BEAR FAMILY

Bears are fun to draw, since their forms are so simple and compact. Work with as many straight lines as possible when drawing them — the tendency is to use too many curves.

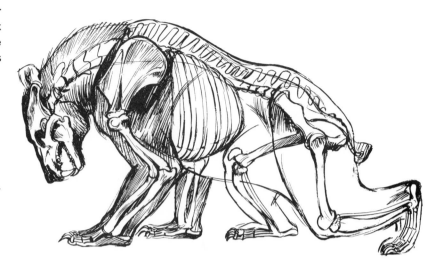

Remember the three body breaks; note bear below.

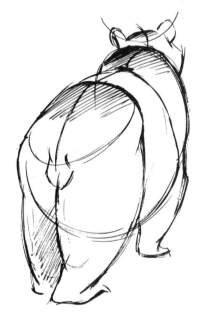

Build on your outer forms when you start, and follow through on the line of action as below, from the rear leg to front leg.

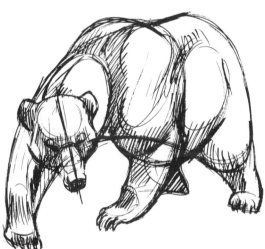

On these quick sketches, note how forms follow through.

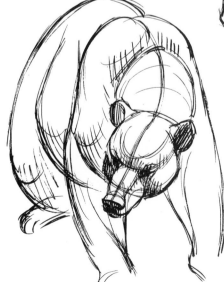

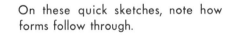

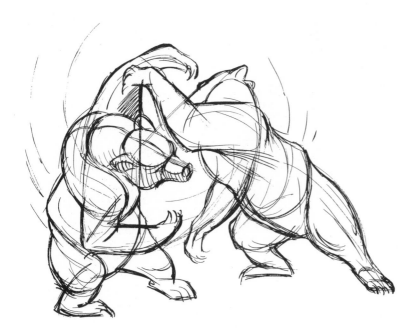

For standing positions, think of the three units which I have indicated below. The high point of the withers breaks the flow of form between the neck and the back.

Observe the use of diagonal and curved lines in this sketch.

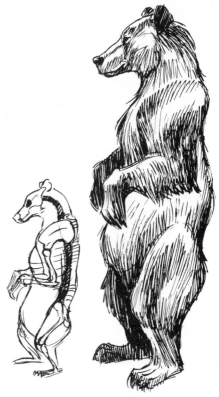

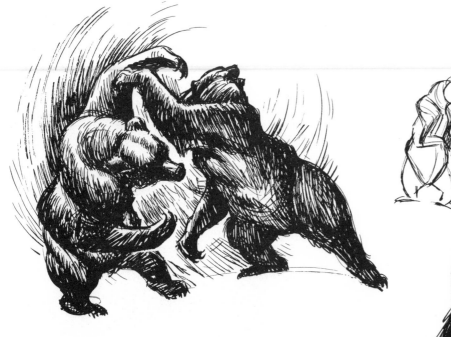

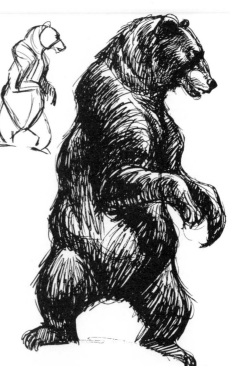

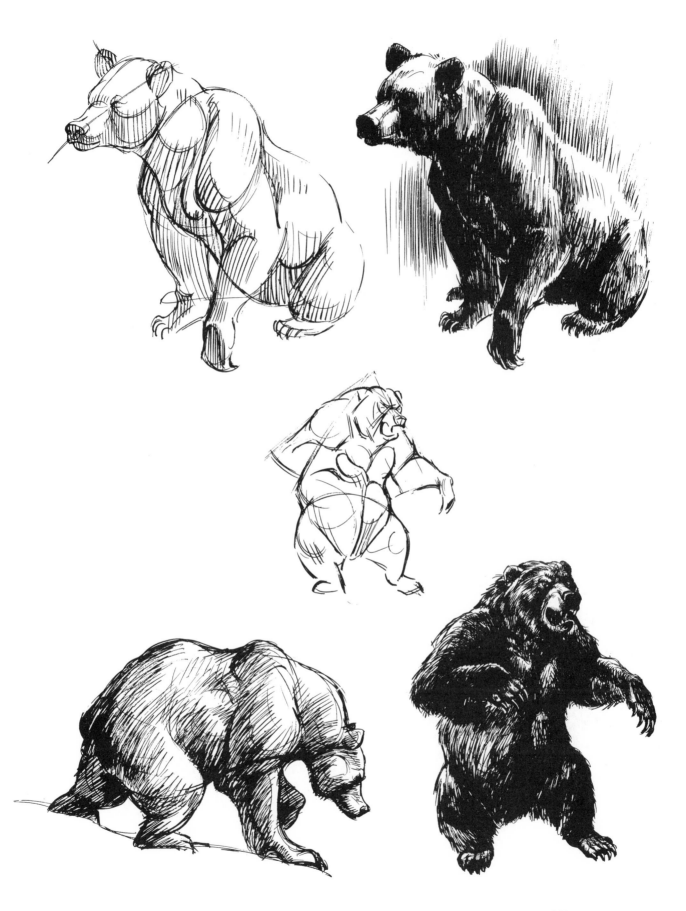

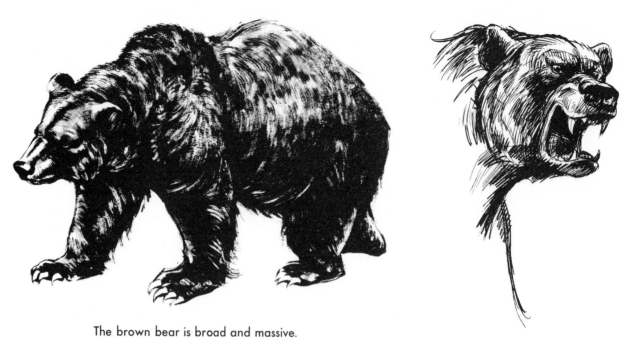

The brown bear is broad and massive.

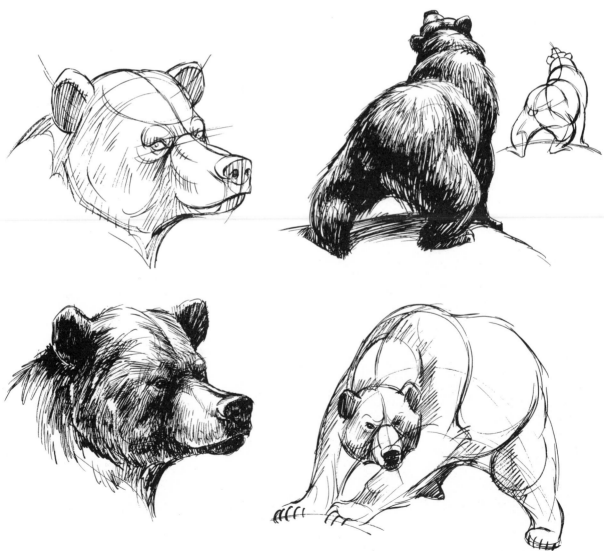

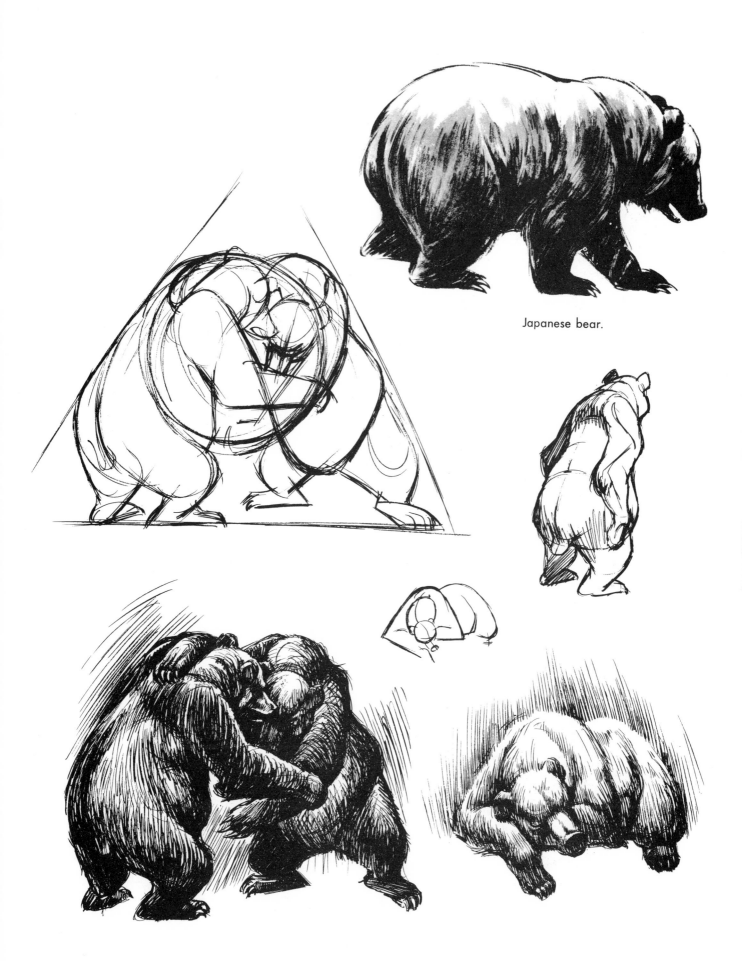

Japanese bear.

123

CUBS

Cubs are small in muzzle and high in crown, which gives them a high forehead. Their bodies are short, and they are slightly pigeon-toed like their parents. Keeping the eyes low in their heads adds to the effect of cuteness.

POLAR BEARS

Polar bears differ from others in that their necks are longer and their noses more pointed. They carry quite a bit of loose hair on the underside, running from the jaw back along the neck, chest, and stomach.

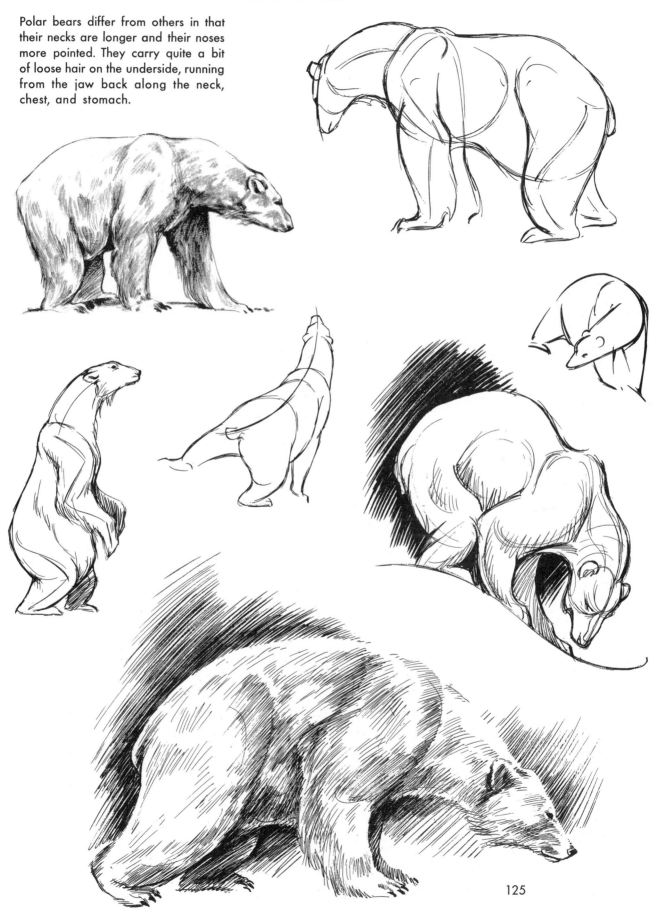

BEARS—CARICATURE

On the adult, exaggerate the large torso and massive "arms." By keeping legs short, you accentuate size of body.

The use of heavy jowls works nicely on bears. For a silly effect, leave out the chin on your character.

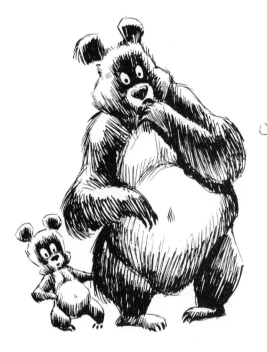

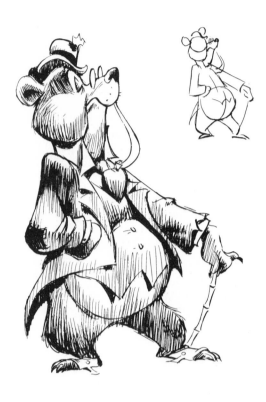

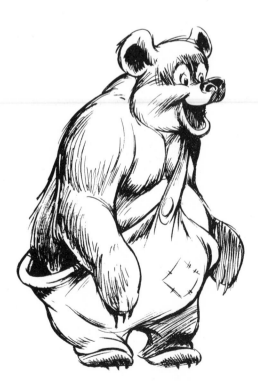

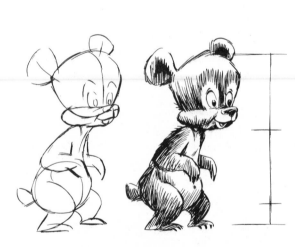

For cuteness in small bears keep the body short and dumpy, the forehead high, eyes low, cheek and stomach full, and the mouth short and small.

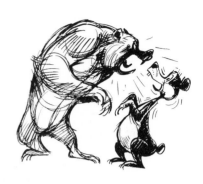

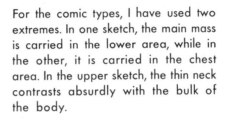

For the comic types, I have used two extremes. In one sketch, the main mass is carried in the lower area, while in the other, it is carried in the chest area. In the upper sketch, the thin neck contrasts absurdly with the bulk of the body.

The polar bear seems to lend itself to a stylized drawing. Here, I exaggerated the long neck, pointed nose, and heavy, long forelegs.

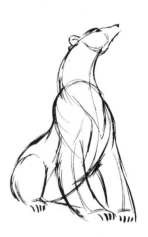

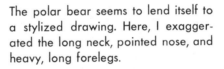

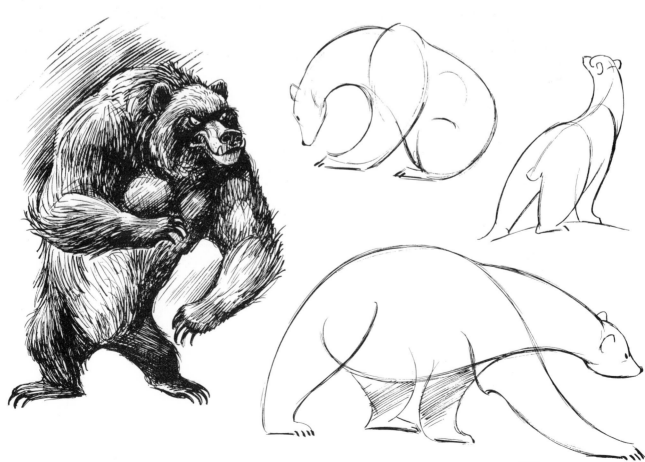

COMPOSITION IN ANIMAL GROUPING

Composition may be an old story to many readers, but for the benefit of those to whom it is new, I should like to summarize some fundamental points. A good picture should be an effective combination of vertical, horizontal, and diagonal lines. There should be opposition, such as a vertical opposing a horizontal line, and repetition, where a line moving in a certain direction is repeated in another part of the picture. Except in abstract compositions, the use of curved lines is natural throughout the picture. It is advisable too, to have a definite line of action in your picture so that the viewer can follow the movement. An accent is always important, since it tends to break the monotony of a line of action.

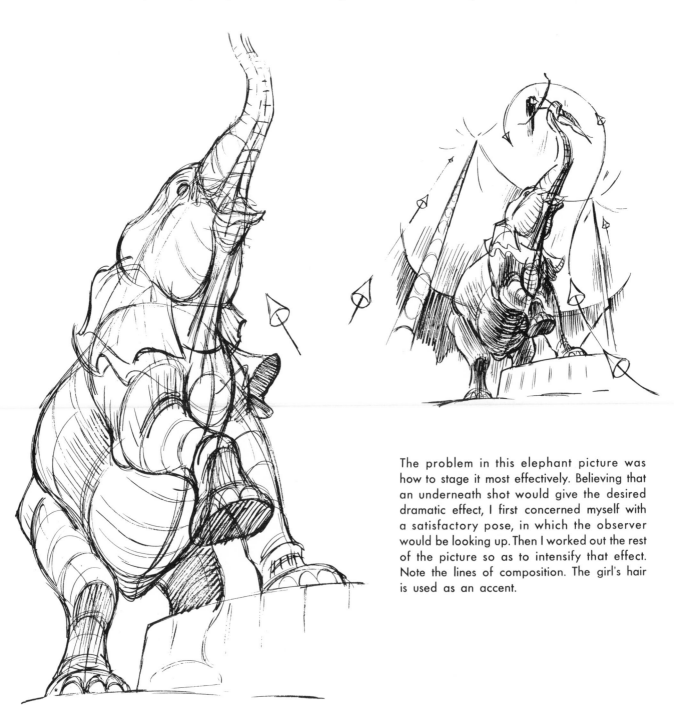

The problem in this elephant picture was how to stage it most effectively. Believing that an underneath shot would give the desired dramatic effect, I first concerned myself with a satisfactory pose, in which the observer would be looking up. Then I worked out the rest of the picture so as to intensify that effect. Note the lines of composition. The girl's hair is used as an accent.

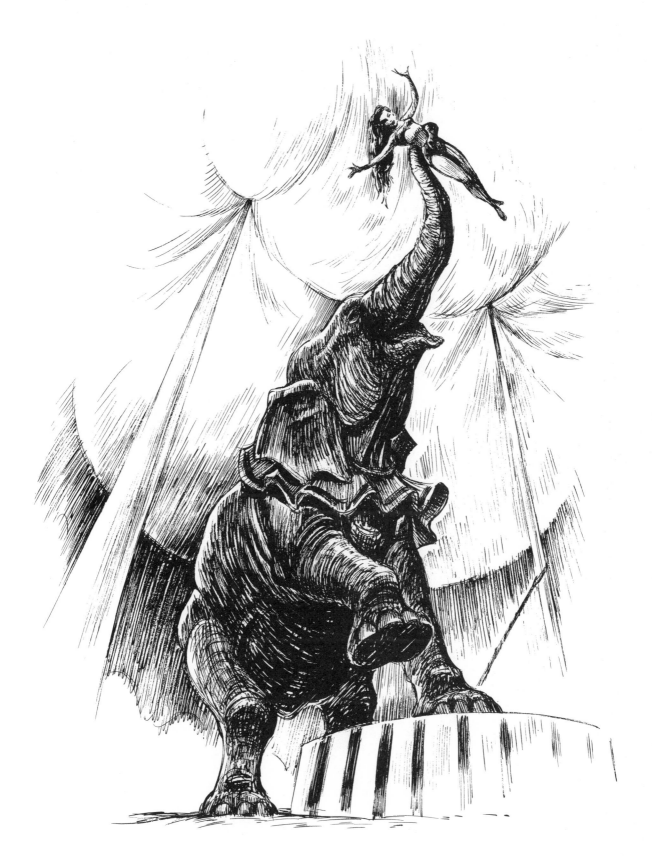

To show the powerful bulk of these draft horses, I used a three-quarter front perspective. For dramatic effect, the camera angle is low, thus accentuating the size of the forequarters and the height of the withers of the horse in the foreground.

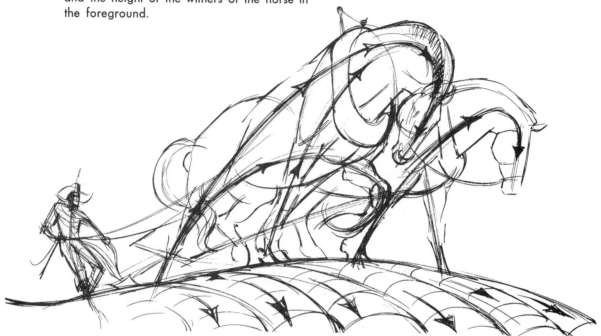

The grooves in the earth give movement to the picture. The grooves, running downhill in the foreground create contrast with the up-angle of the foreground horse.

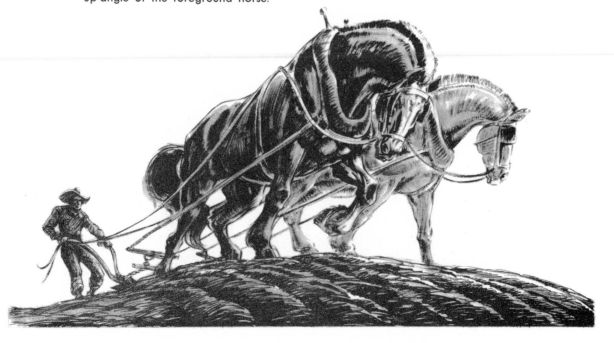

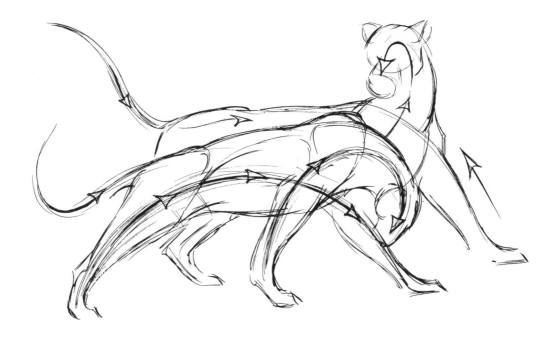

The arrows indicate the paths of action.
The panther's head in the background
is used as the accent.

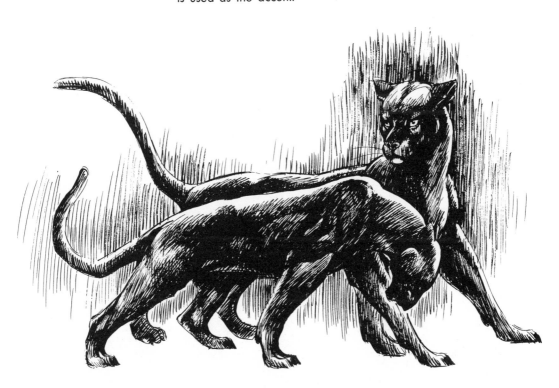

In this layout, the use of diagonal, vertical, and horizontal lines is emphasized. A strong vertical, such as the left foreleg of the horse in the foreground, tends to hold the picture together. Note how it leads into the three heads. The rear horse's head is the accent. Observe the right foreleg of the horse in the lead. It furnishes a good diagonal to the picture, as well as extending in the direction of the rear horse's head. (See arrows in sketch.)

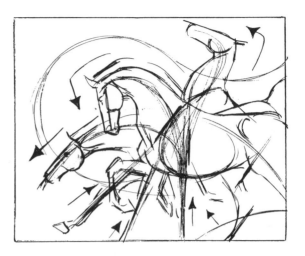

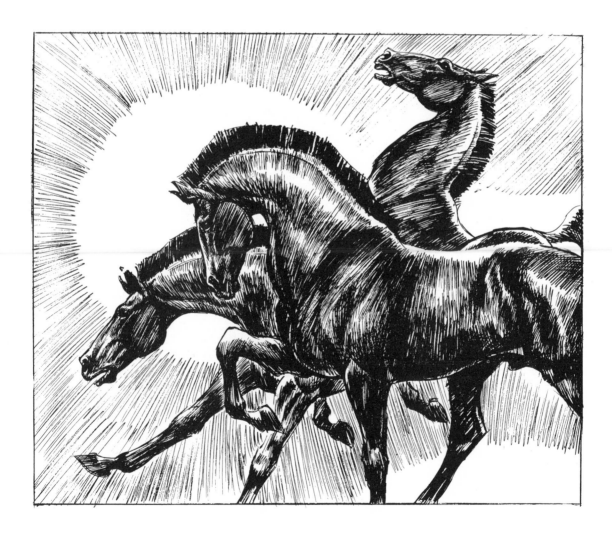

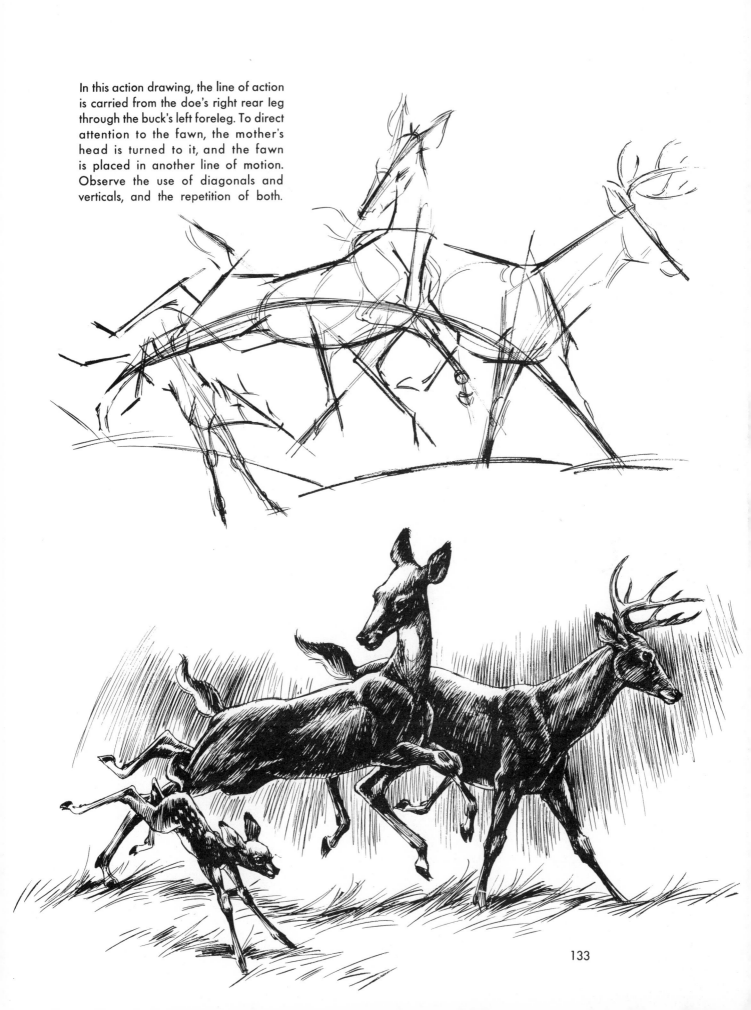

In this action drawing, the line of action is carried from the doe's right rear leg through the buck's left foreleg. To direct attention to the fawn, the mother's head is turned to it, and the fawn is placed in another line of motion. Observe the use of diagonals and verticals, and the repetition of both.

133

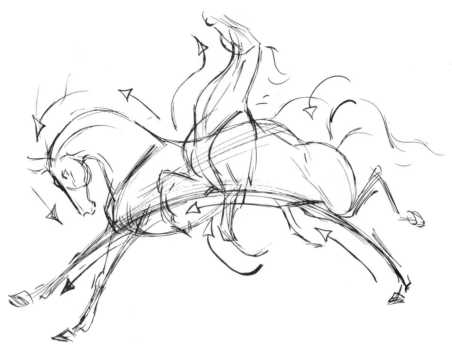

Again in this drawing, the various paths of action are indicated by arrows. A strong line of action from the right hind leg of the rear horse follows through to the left foreleg of the front horse. Here, the rear horse's head works as an accent. The angle of the front horse's head is in opposition to the line of his left foreleg. The left foreleg of the rear horse gives a vertical line to the, picture.

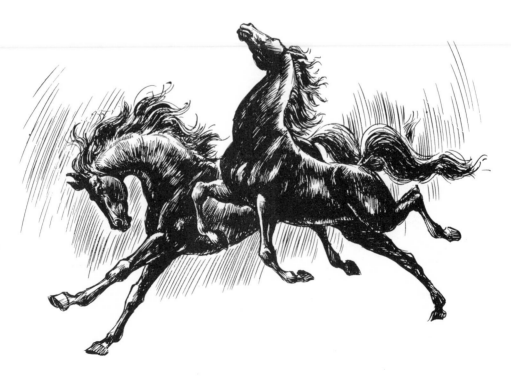